———————

I DON'T KNOW MUCH ABOUT ART
BUT I KNOW WHAT I LIKE

———————

I Don't Know Much About Art
But I Know What I Like

a rejection of rejection

Marjorie Bull

DEDICATION

In memory of my mother,
who honestly believed I could do anything
if I just put my mind to it,

and for my big brother
who heckled me until I wrote this book.

Copyright © 2013 by Marjorie Bull
Lockport, Illinois

All Rights Reserved

ISBN-13: 978-1489534293

INTRODUCTION

As a teenager, I often wished that I could take beautiful pictures like those in magazines and advertisements. So when retirement finally came along, I spent some quality-time with my best camera (a Canon point-and-shoot), selected my ten best pictures, and submitted them to a stock agency to see if they showed any promise at all.

To my delight, three were accepted. Encouraged, I kept clicking the shutter and sending the results to the agency. Two months later, I had my first sale, and earned the whopping commission of 34 cents! *It's more than most people ever make with their photography,* I told myself, and gleefully sent them more photos.

Always about a third were accepted, and after a few months had passed, I began to wonder if that number could be increased. So I studied other people's work. I invested in a better camera. I read all I could find about composition, lighting, and editing techniques. Over the next three years my acceptance rate has risen steadily, until now almost two thirds of my submissions are accepted.

Why are the other third rejected? Sometimes there are technical flaws I missed in editing. Some are pictures I don't much like myself, but I dislike many pictures in the agency's library, so I send them anyway; if they are rejected it's no surprise. Some represent my moments of manic joy in Photoshop, using special editing effects which may or may not have commercial appeal. But there are some I simply don't understand. I look at them and know, *know,* beyond any doubt, that they are really good.

So I decided to make a little book of a few of my best photos that, for whatever reason, just didn't make the cut. And here it is. I hope you'll enjoy these "rejects" as much as I do.

<div style="text-align: right;">MarjorieB</div>

P. S. Now and then I resubmit a picture I really like, either "as is" or with minimal changes, and several of those in this book have been accepted on their second time around. I can only suppose that the reviewer had had a good sleep the previous night and a good strong cup of coffee that morning. M.B.

PICTURES

Discover the wonder

of the everyday

every day.

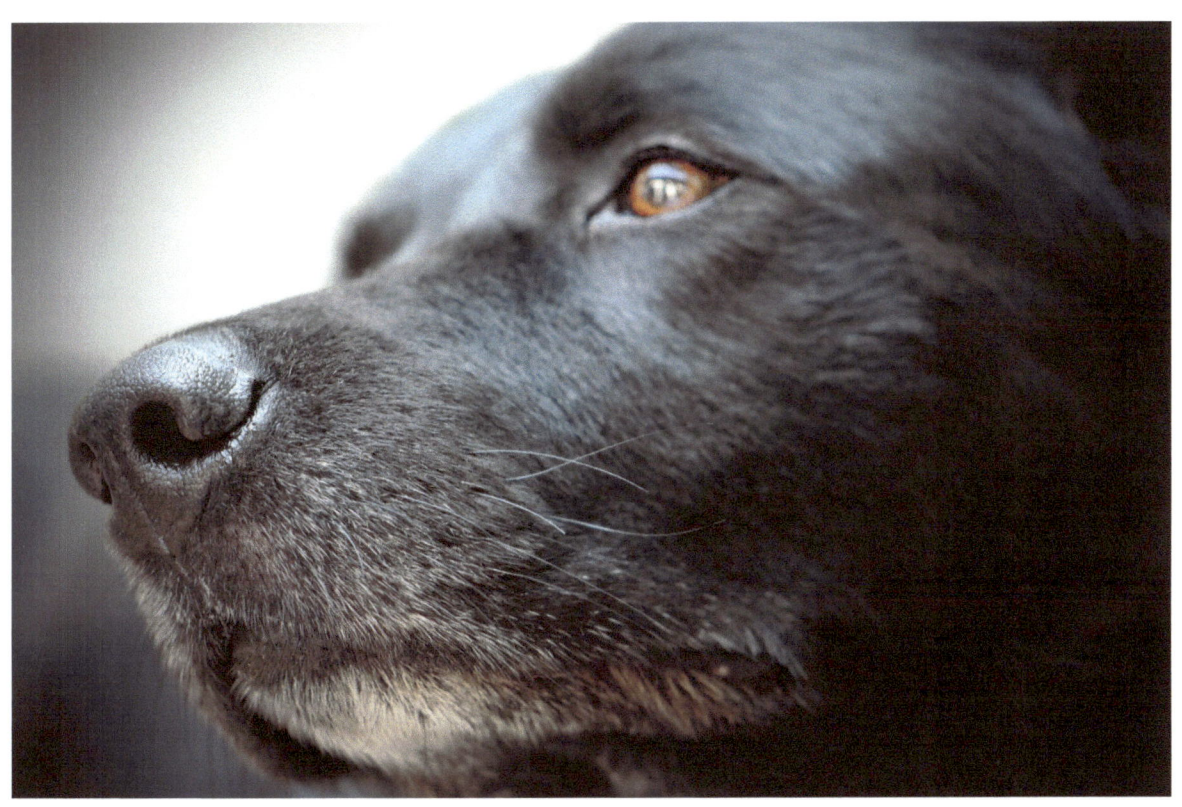

Thor, my faithful companion and best friend.

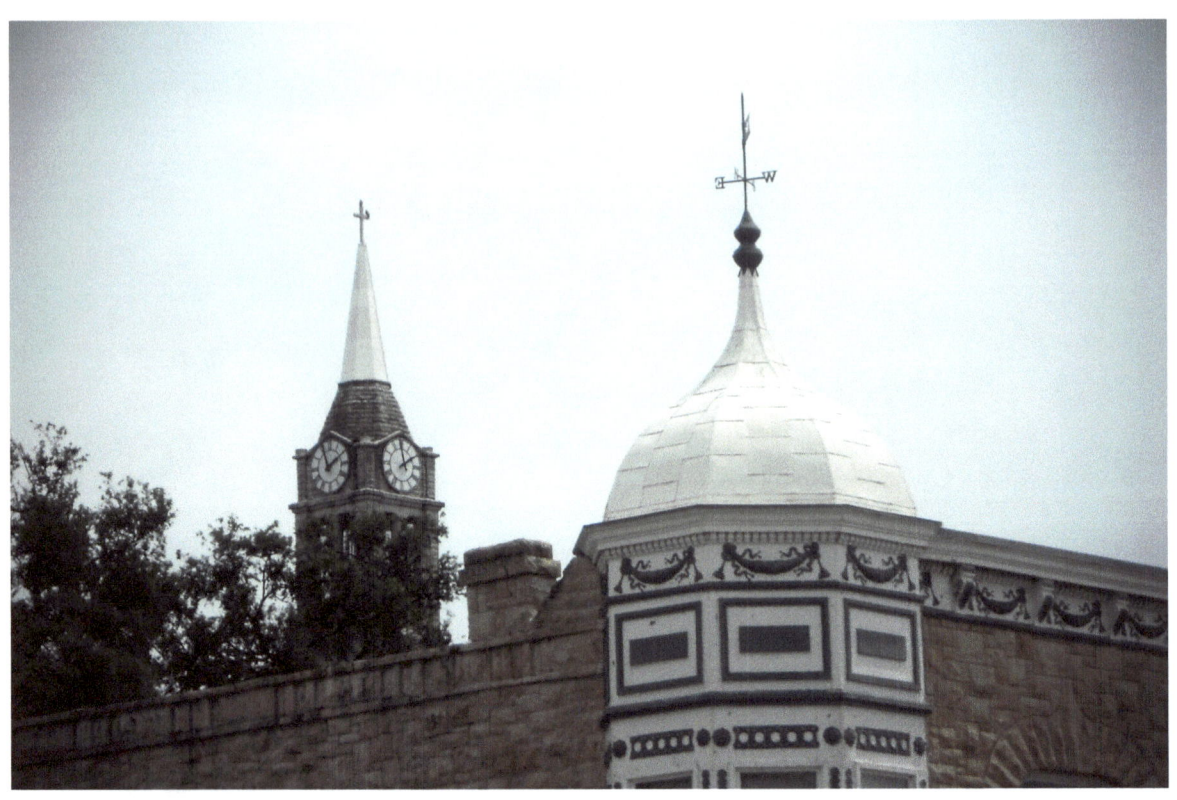

Cross and weathervane punctuate the skyline. The "onion" dome graces a restaurant, and the church steeple is St. Dennis Catholic Church in Lockport, Illinois. Both buildings are constructed of Joliet limestone in Richardsonian Romanesque style.

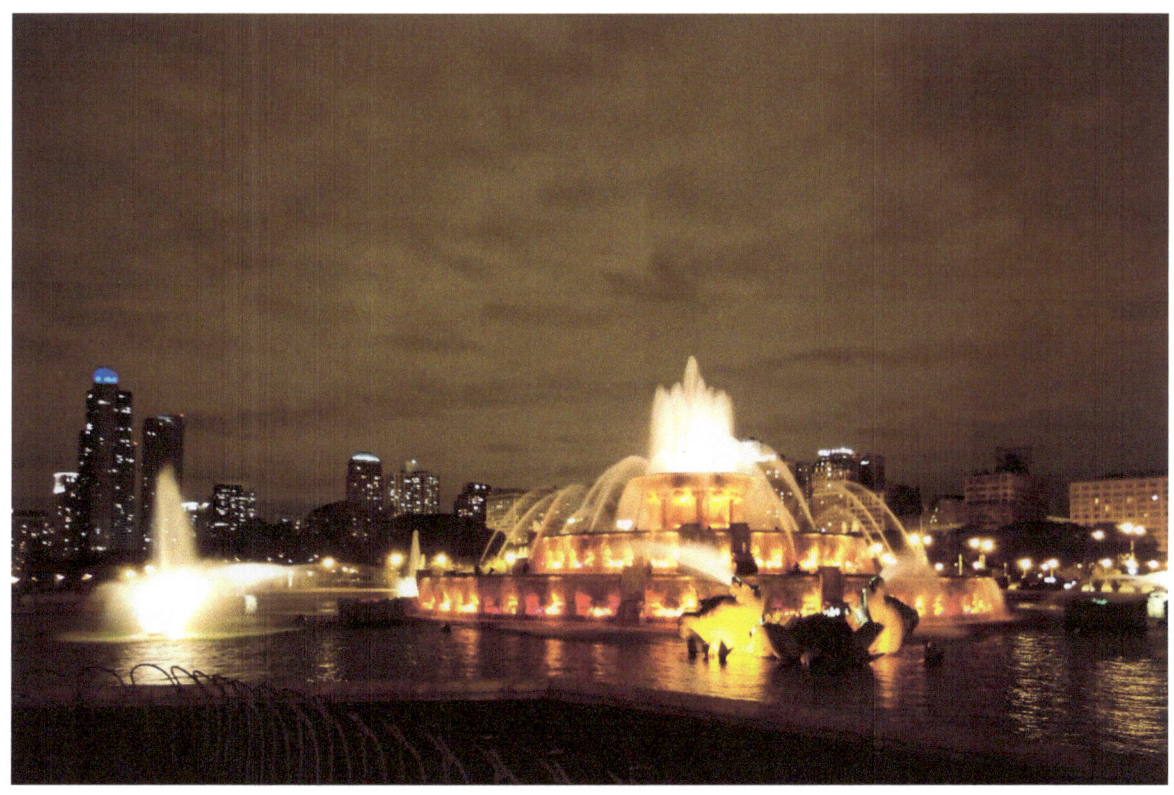

Chicago, Illinois. Buckingham Fountain's ever-changing colored light show is displayed every evening during the warmer months of the year.

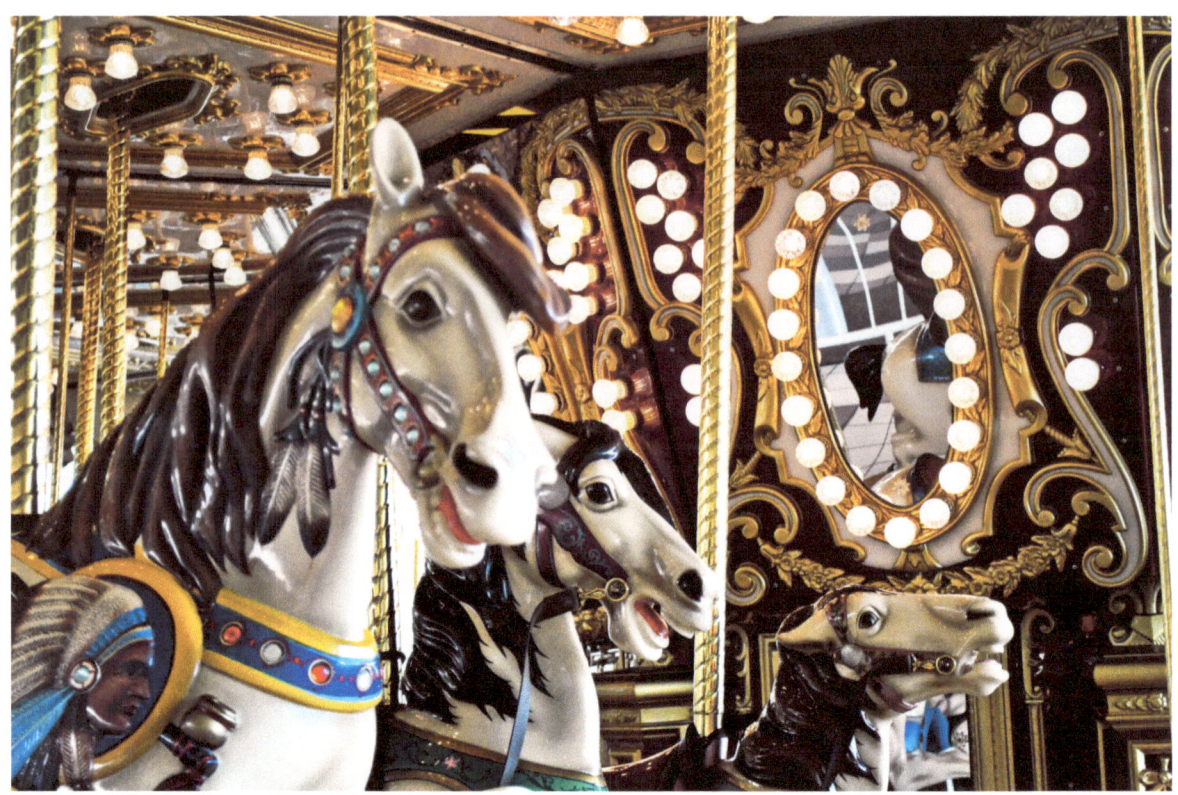

The carousel ponies offer a ride into fantasy and glamour.

RIGHT: So does a really BIG red balloon. The young lady's date was a party planner who had just brought off a huge public event in downtown Chicago.

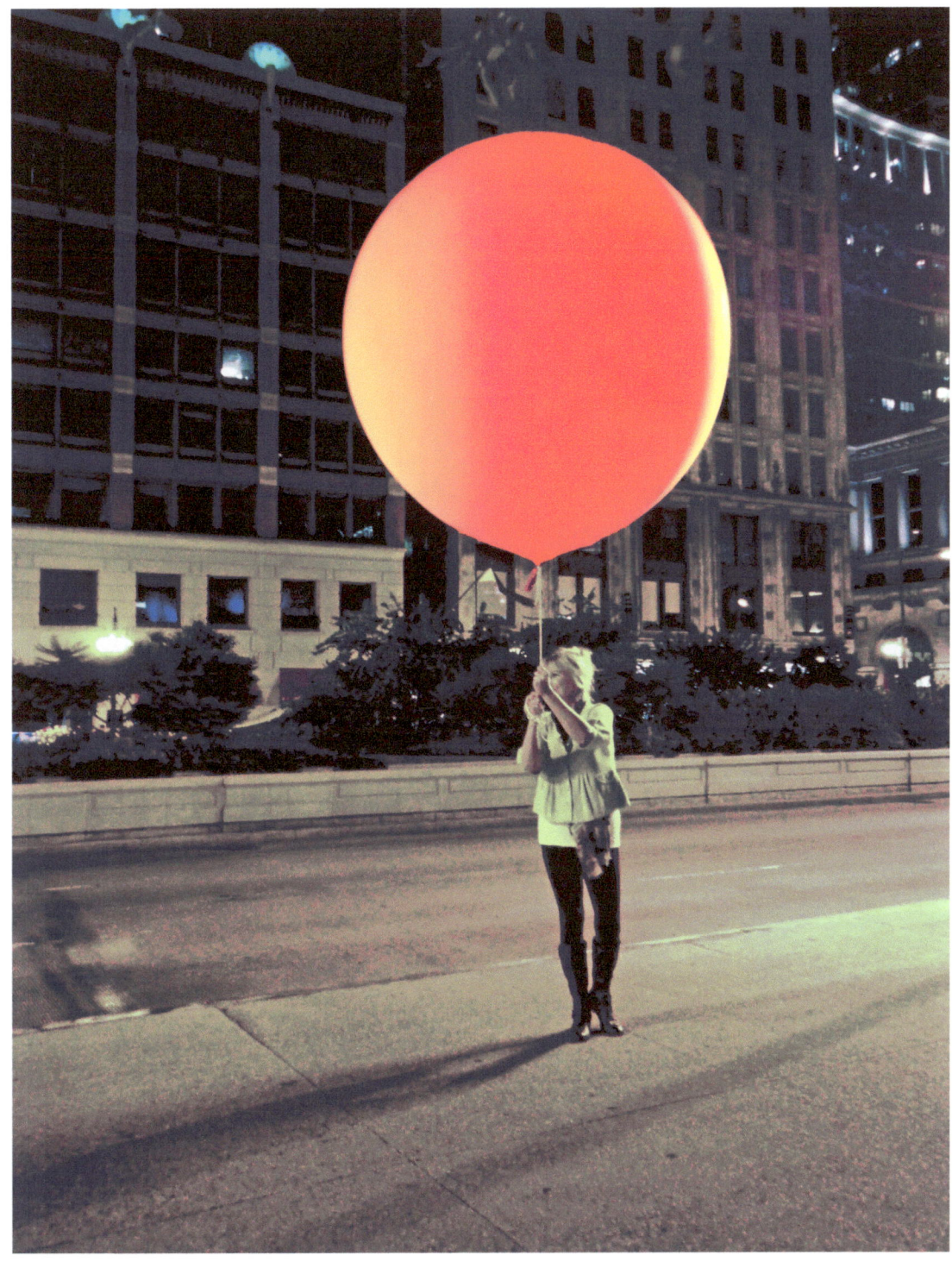

I Don't Know Much About Art But I Know What I Like 5

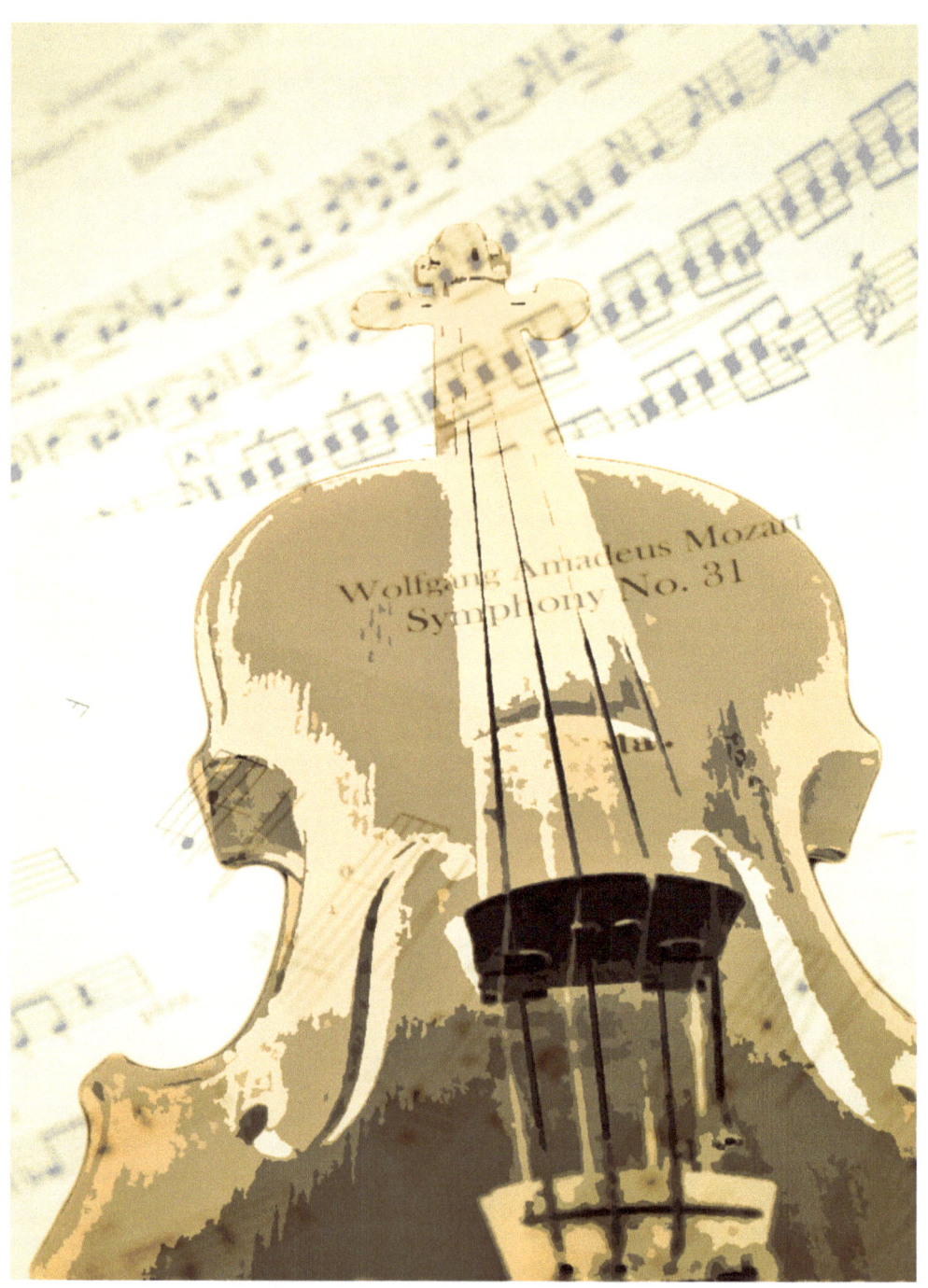

Viola with orchestra music.

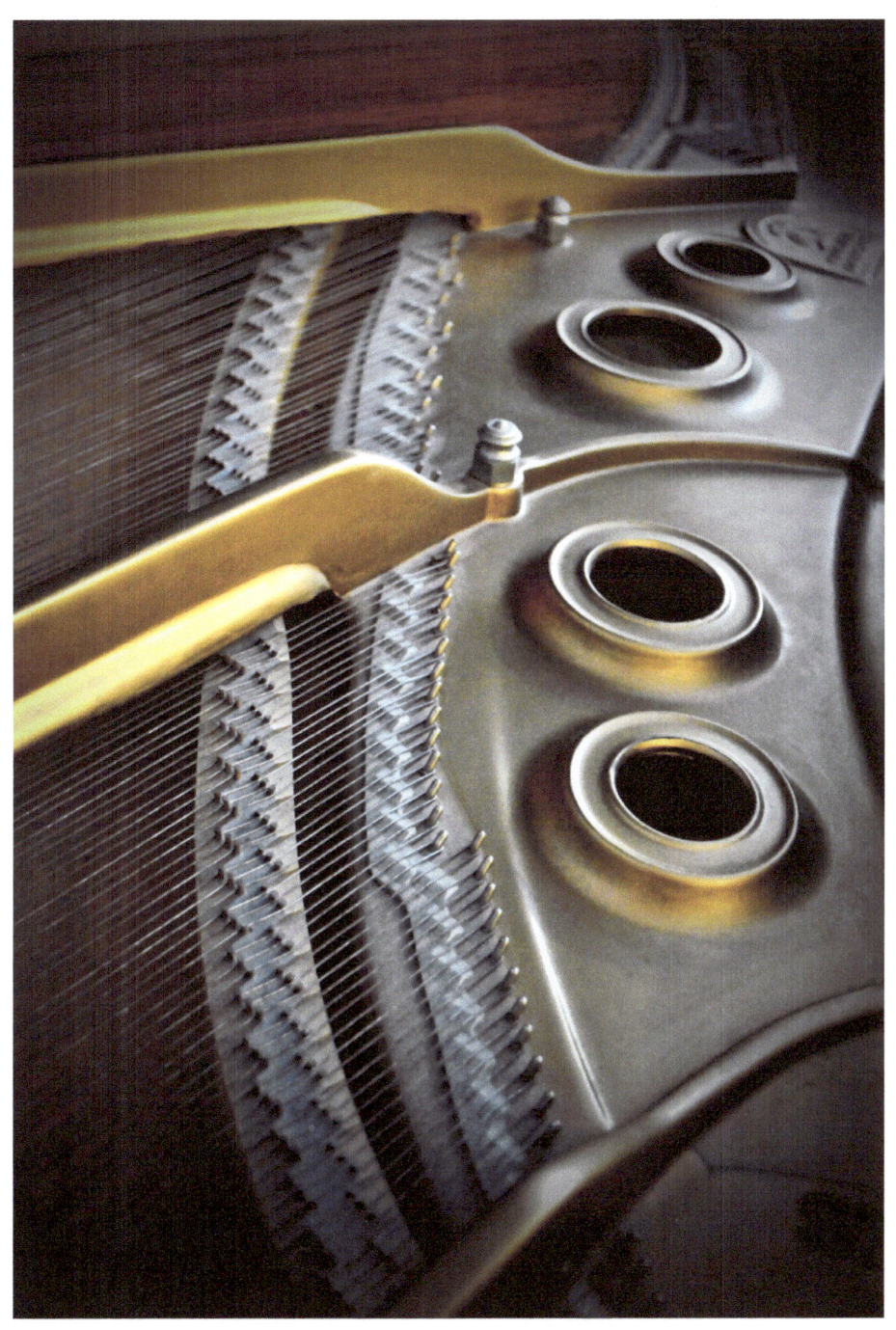

Interior of a baby grand piano.

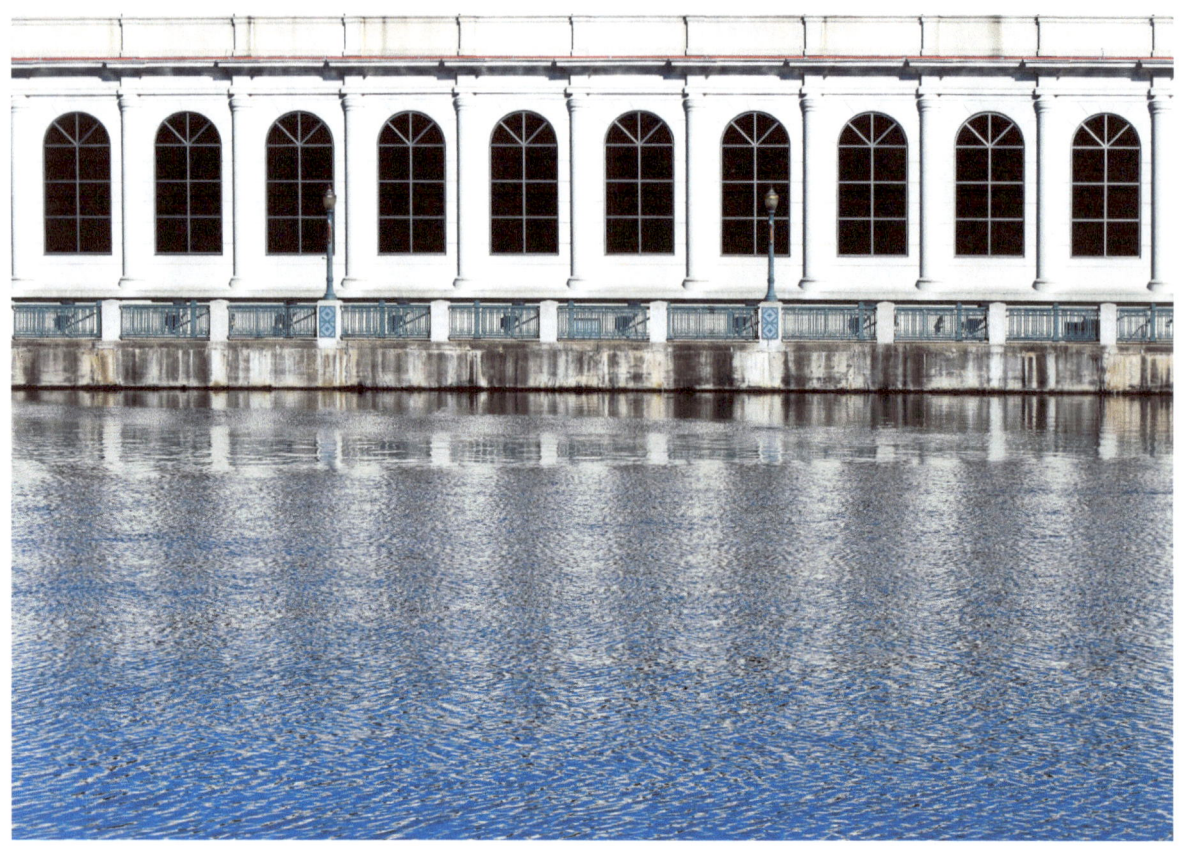

A view of the water: arched windows are reflected in the waters of the Du Page River at Joliet, Illinois.

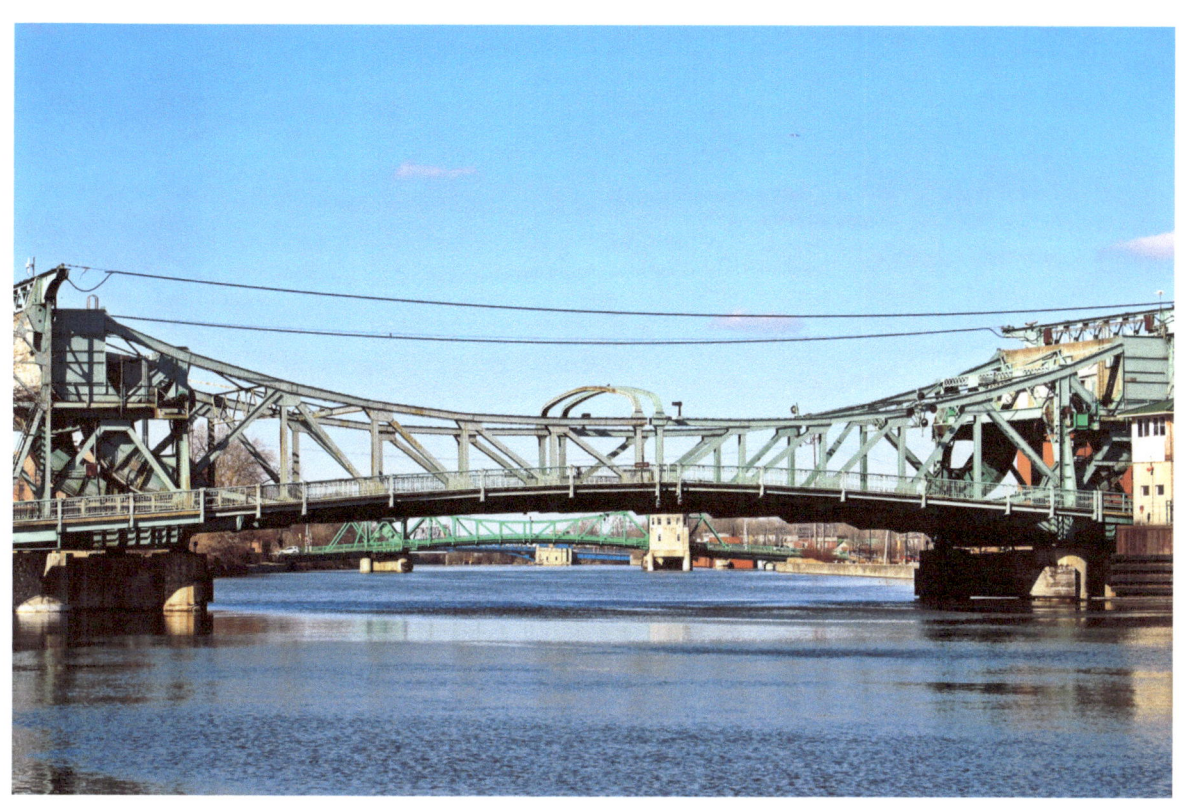

View of the Cass St. bridge, Joliet, Illinois.

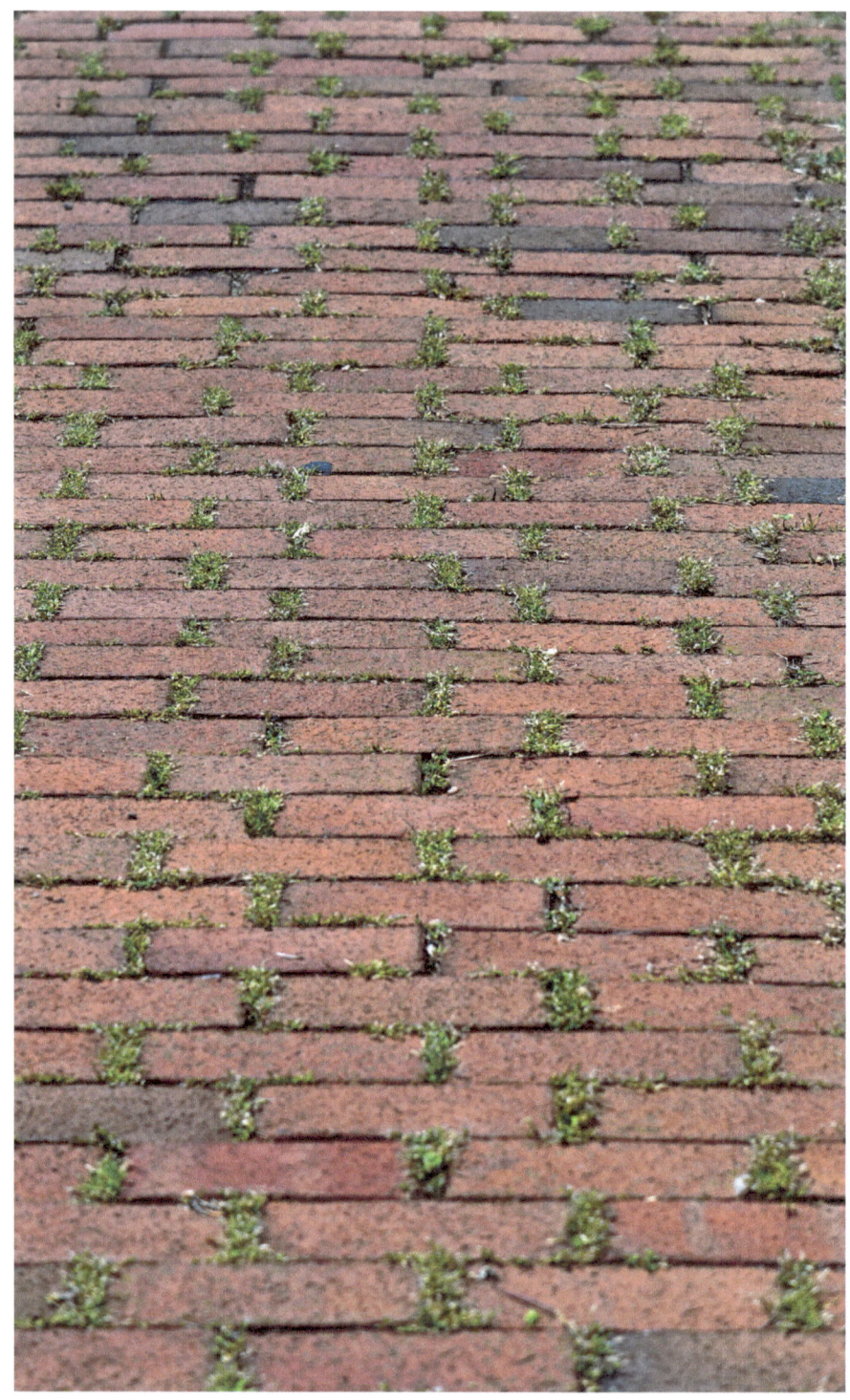

ABOVE: The many colors and patterns of brickwork fascinate me.

LEFT: I thought at first this was just evidence of a botanic determination to grow no matter what the obstacle. Then I looked again—the bricks are purposely set apart. The tufts of green are part of the gardener's design.

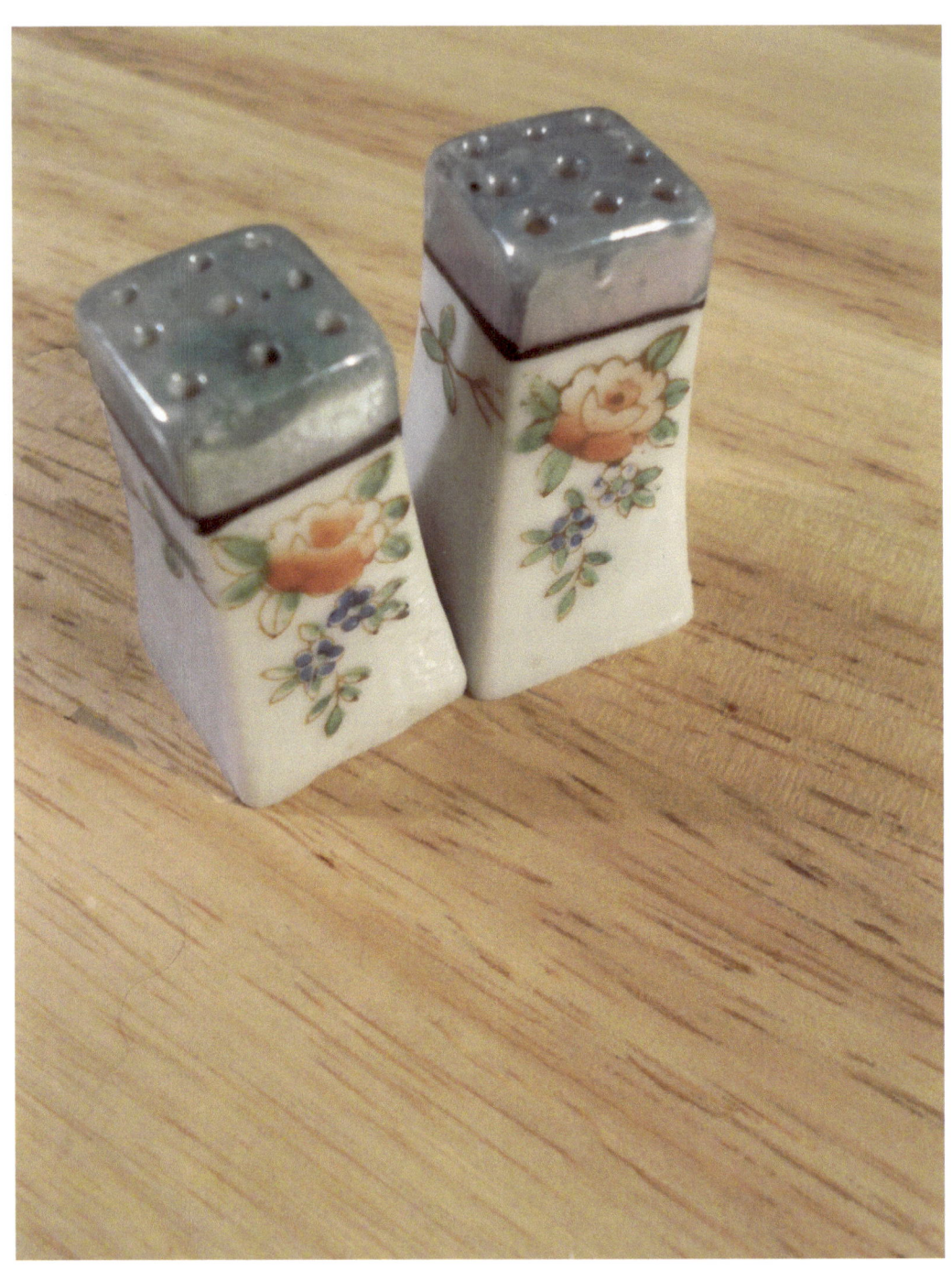

Salt and pepper shakers made in Japan, circa 1930s.

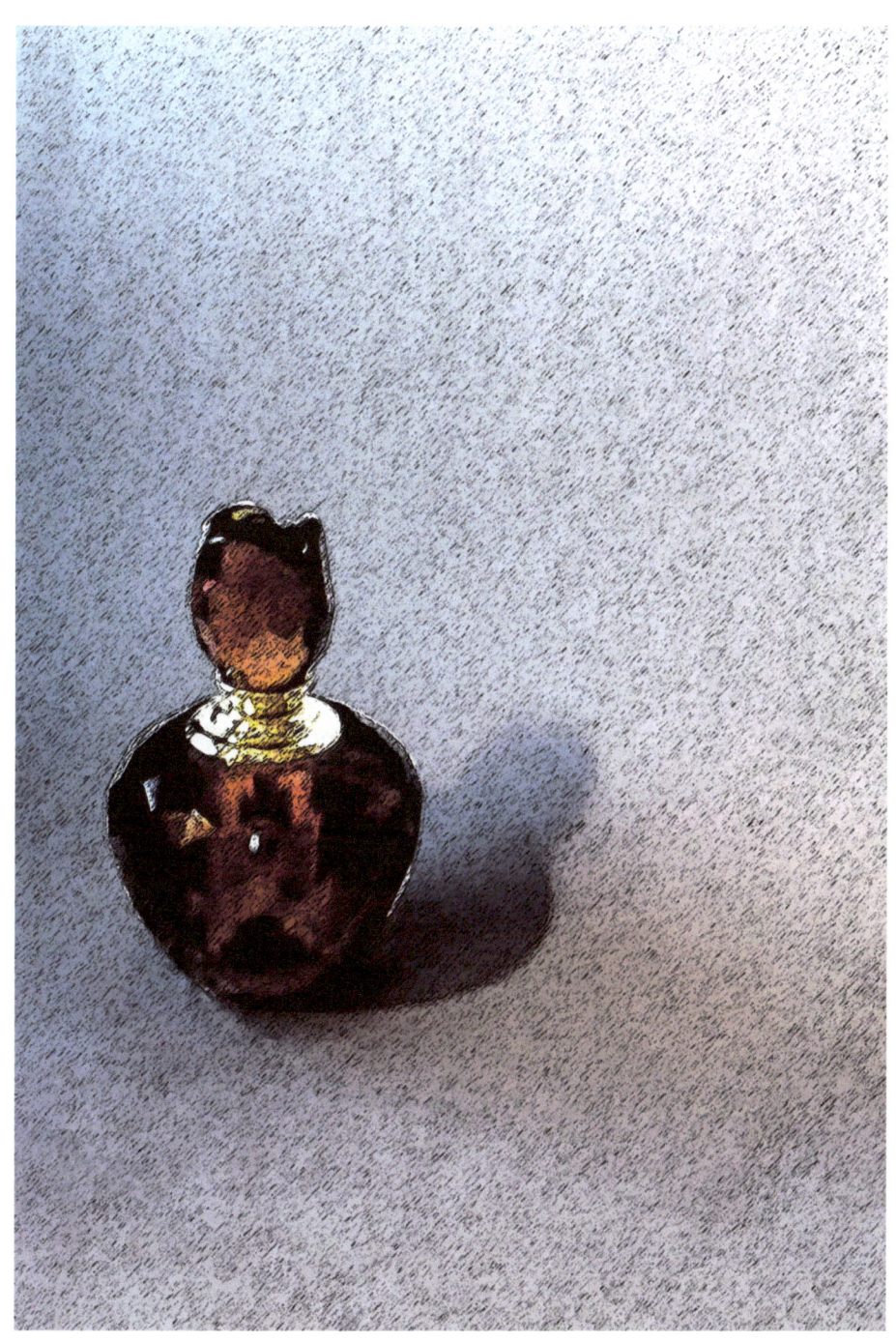

Glass perfume bottle with a few editing effects.

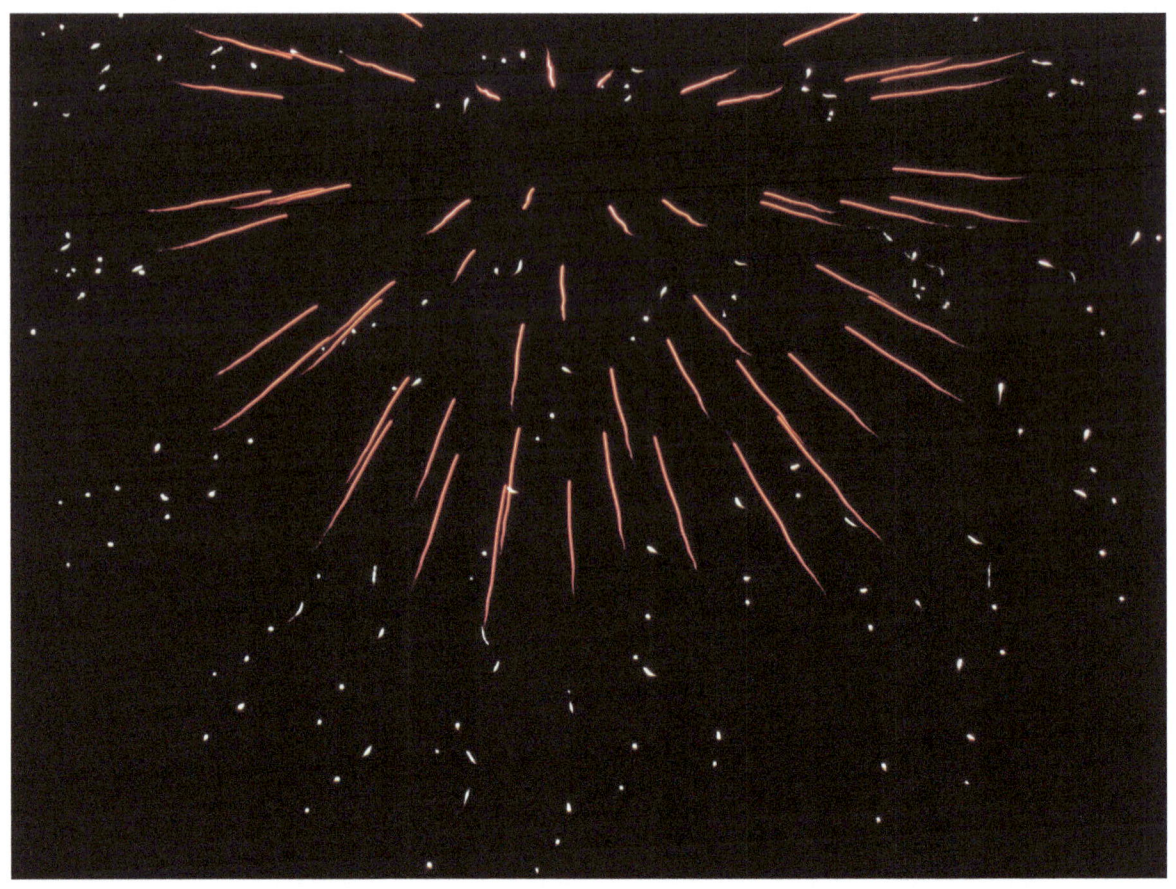
One perfect starburst of fireworks. RIGHT: when you can't get it all in one shot, make a composite of seven photos.

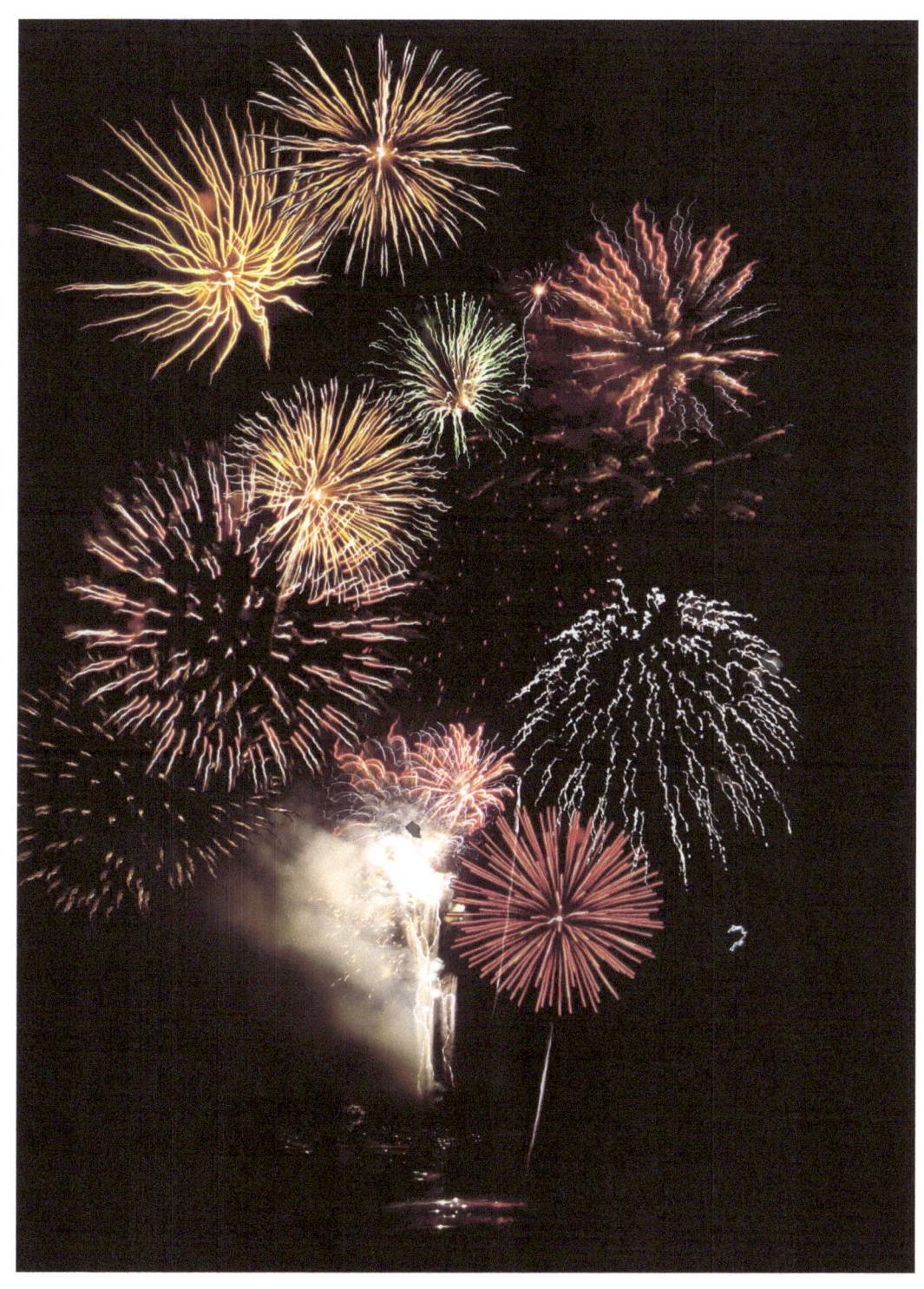

I Don't Know Much About Art But I Know What I Like

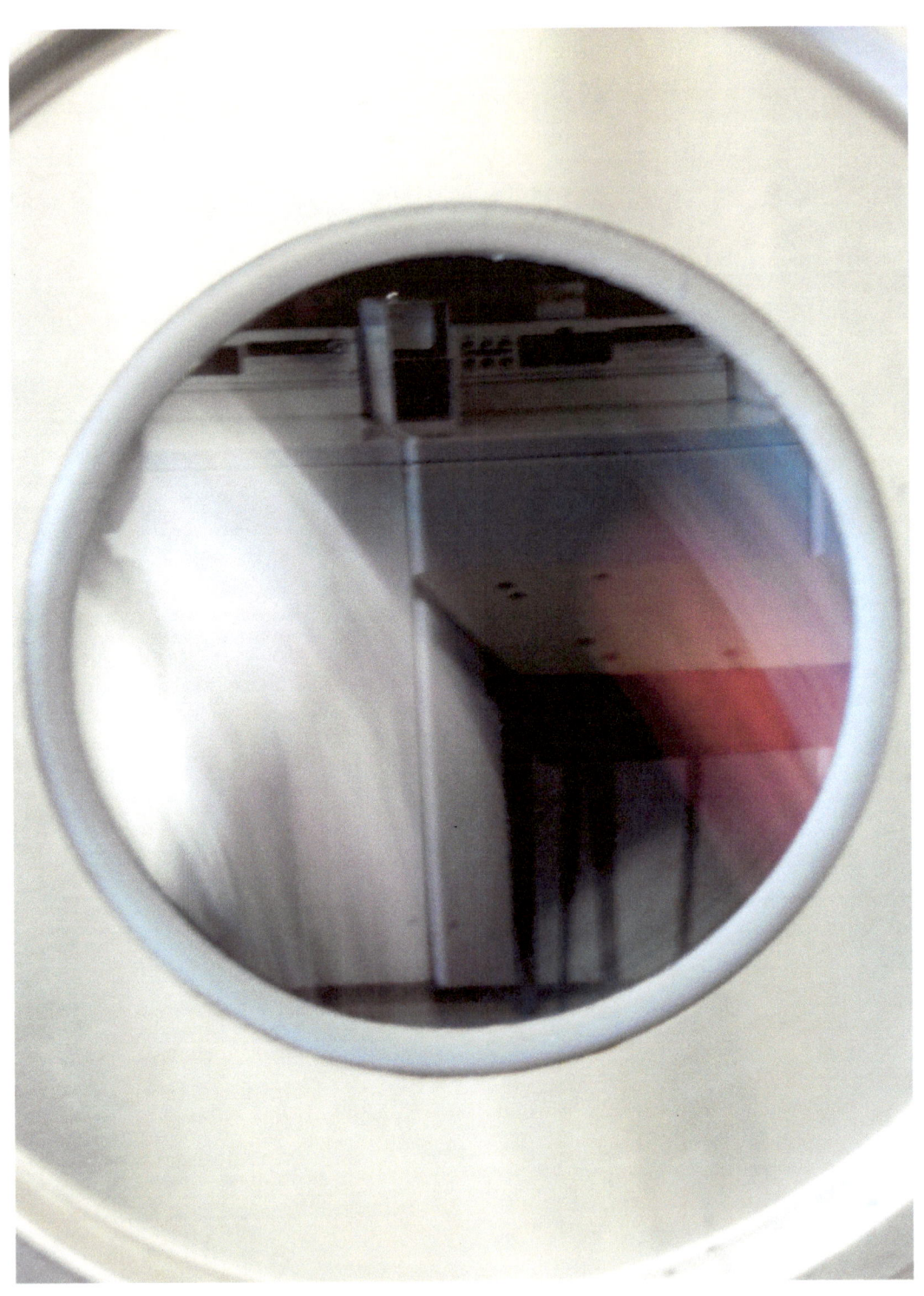

I Don't Know Much About Art But I Know What I Like

My inner child loves splashing water as much as any kid.

LEFT: One snap captures the whole morning's work—the dryer window reflects the coin-operated washing machines and the folding table, while behind the glass the clean clothes tumble merrily round and round.

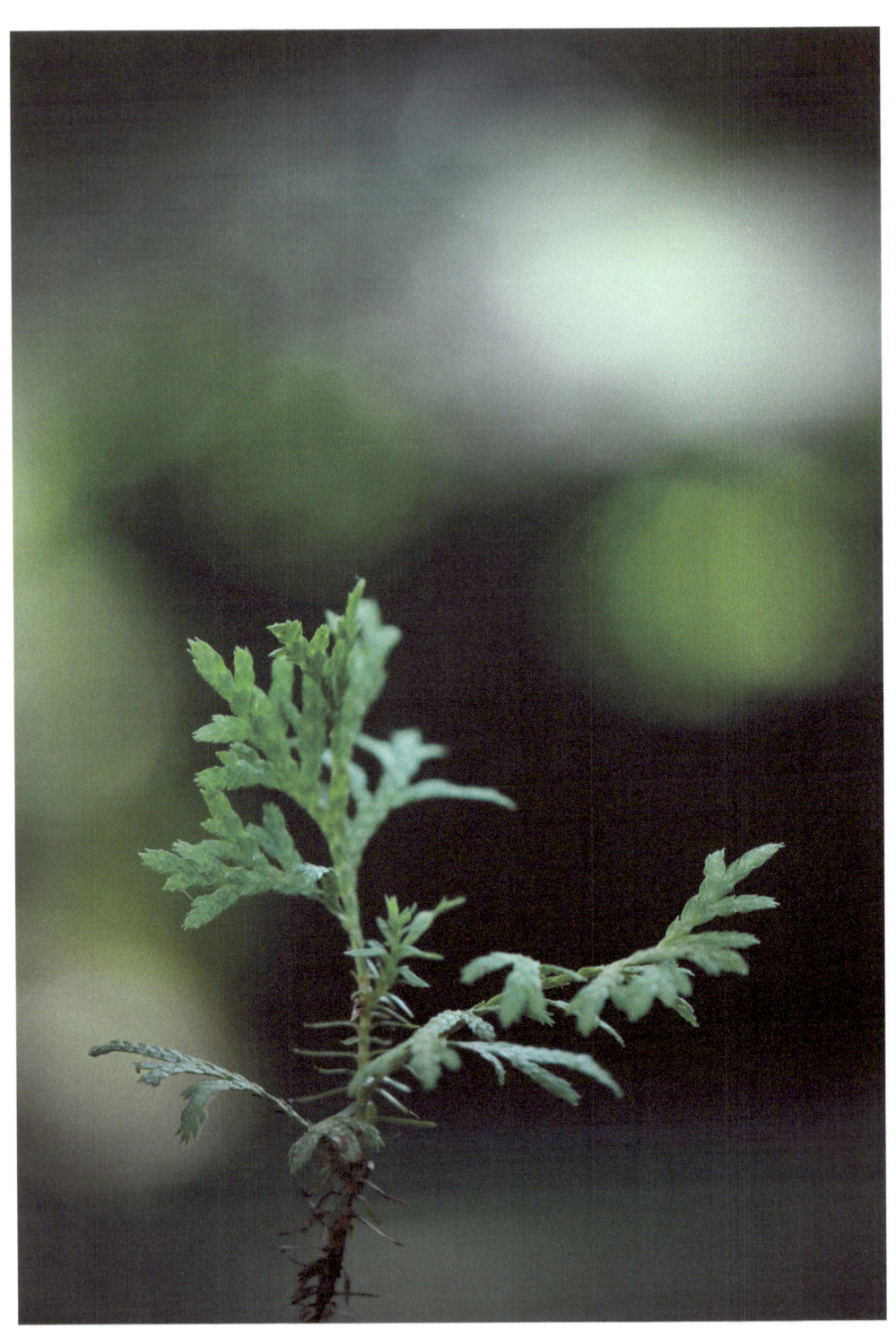

I Don't Know Much About Art But I Know What I Like

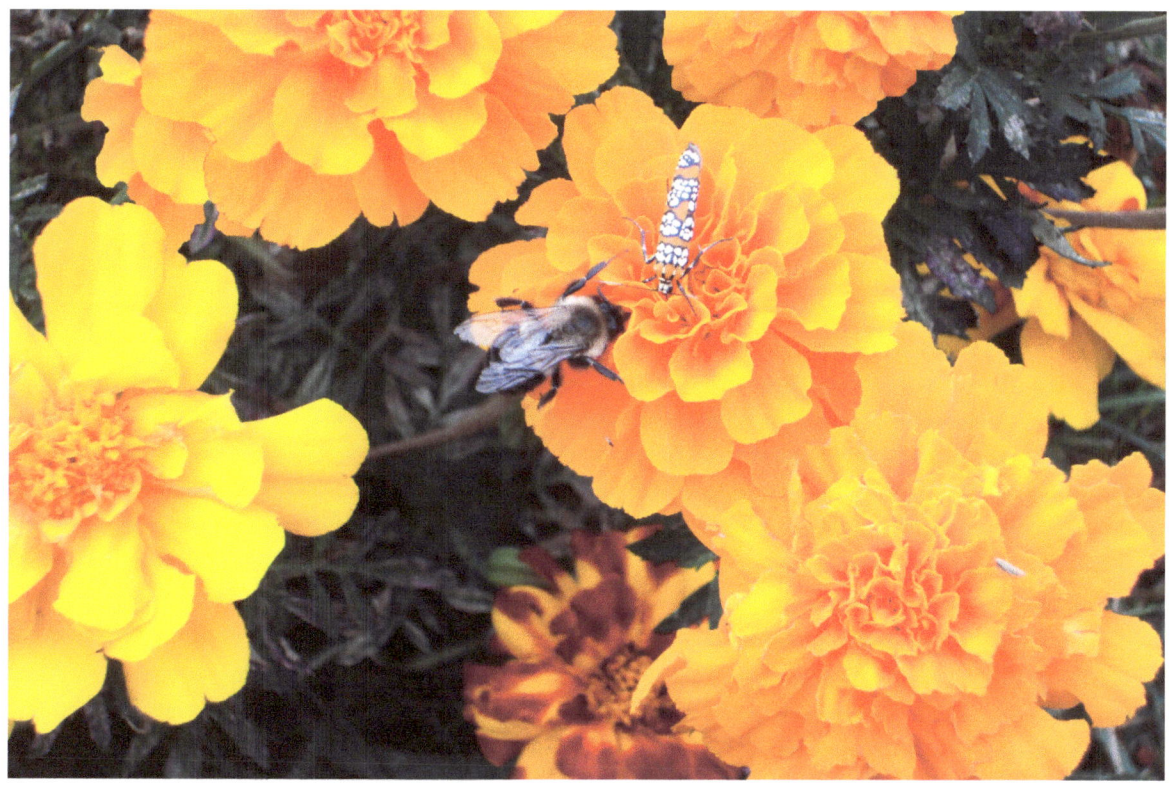

I had just focused in on the leafhopper (the orange insect with the bold black and white patterns) when suddenly the bumblebee buzzed himself in and began to feed. I snapped the shutter as fast as I could and got out of there *pronto*. There are four insects in this picture; can you find them all?

LEFT: a tiny *arbor vitae* tree that "volunteered" in my garden, the offspring of one I had just lost in a storm the previous winter.

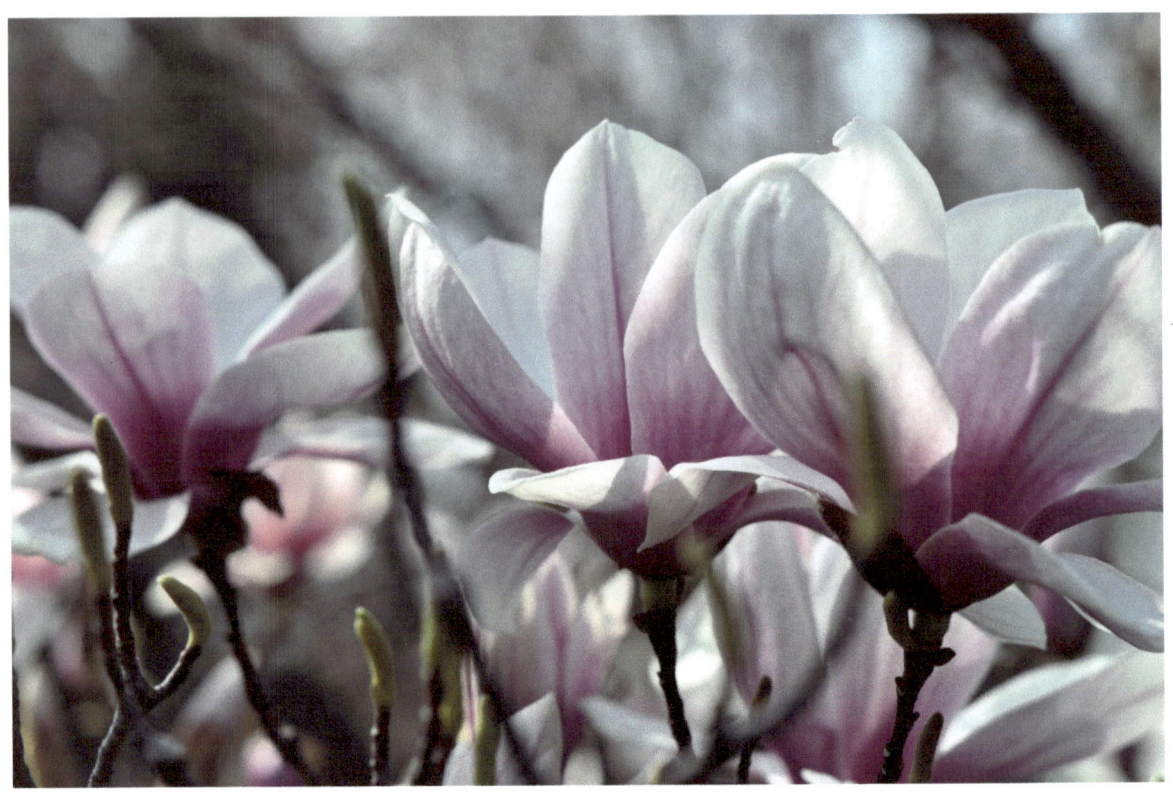

Morning sunlight touches the magnolia blossoms on the tree in the back yard that my mother planted so many years ago.

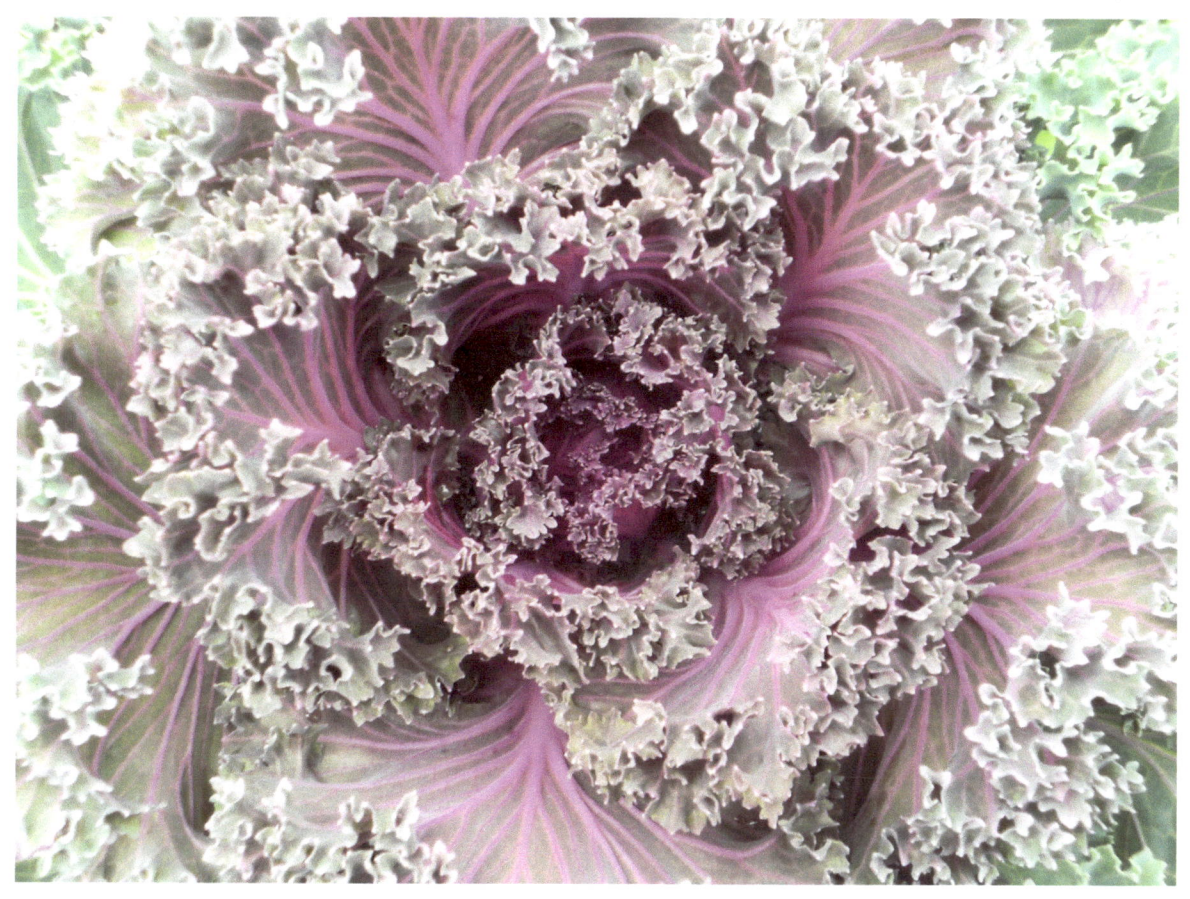

Ornamental cabbage, a natural fractal design.

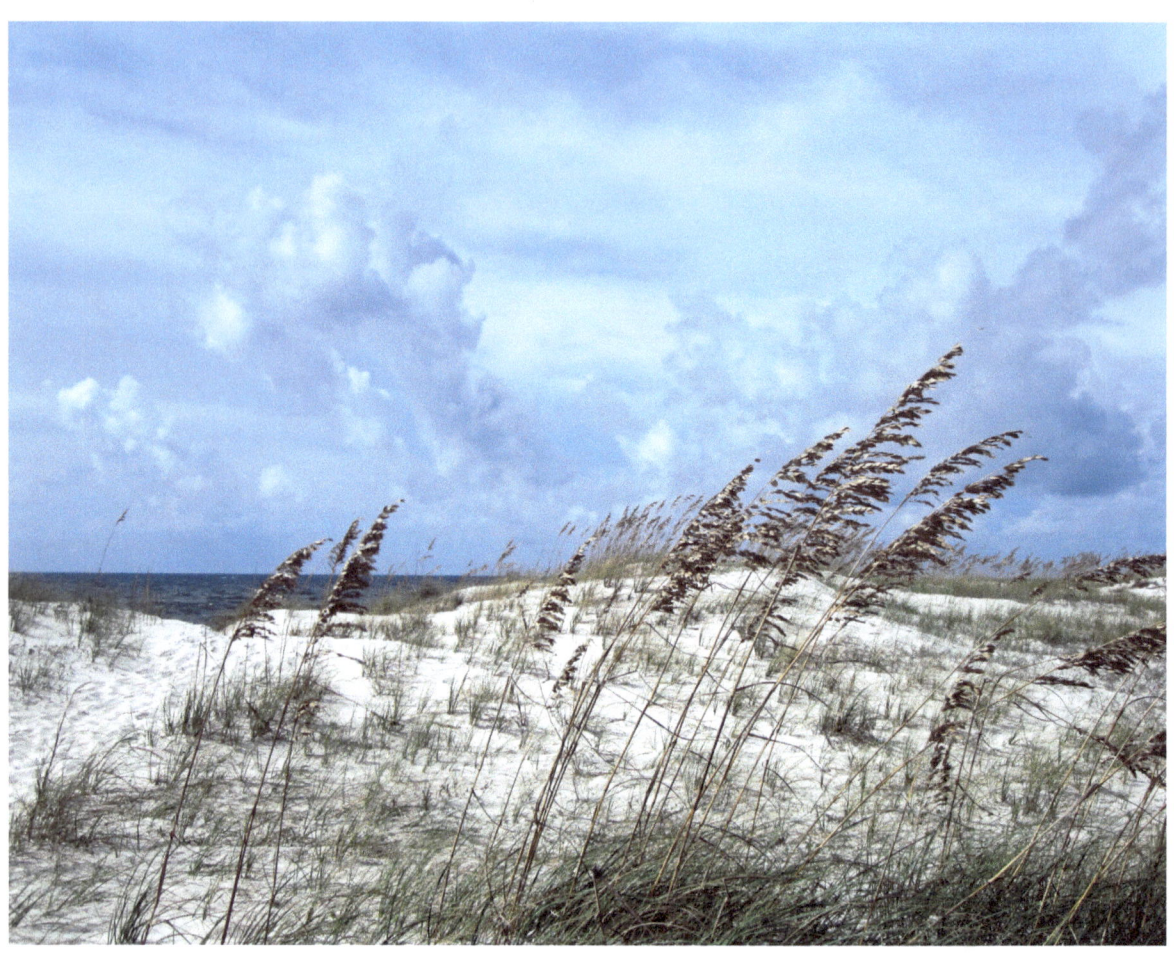

A glimpse of the Gulf of Mexico above the dunes. Sea oats hold the white sand against the erosion of wind and waves. Perdido Key, Florida

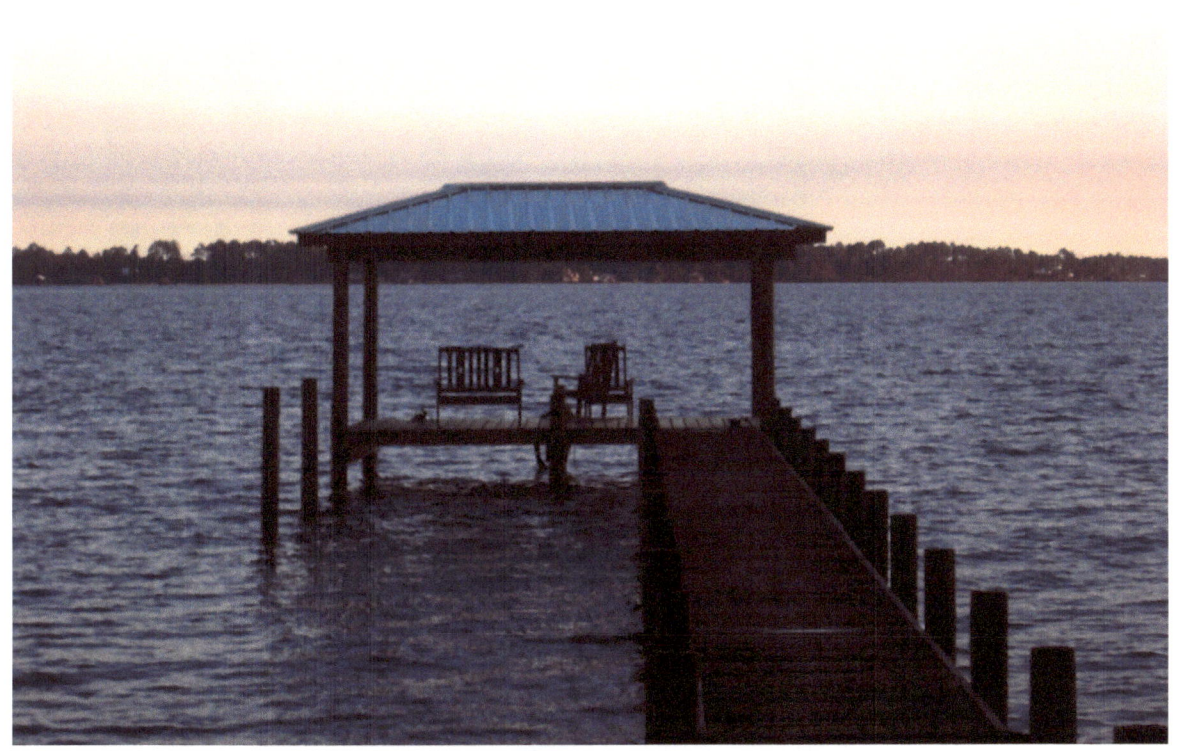

Pink sunset lingers on into the evening on Perdido Bay, Florida.

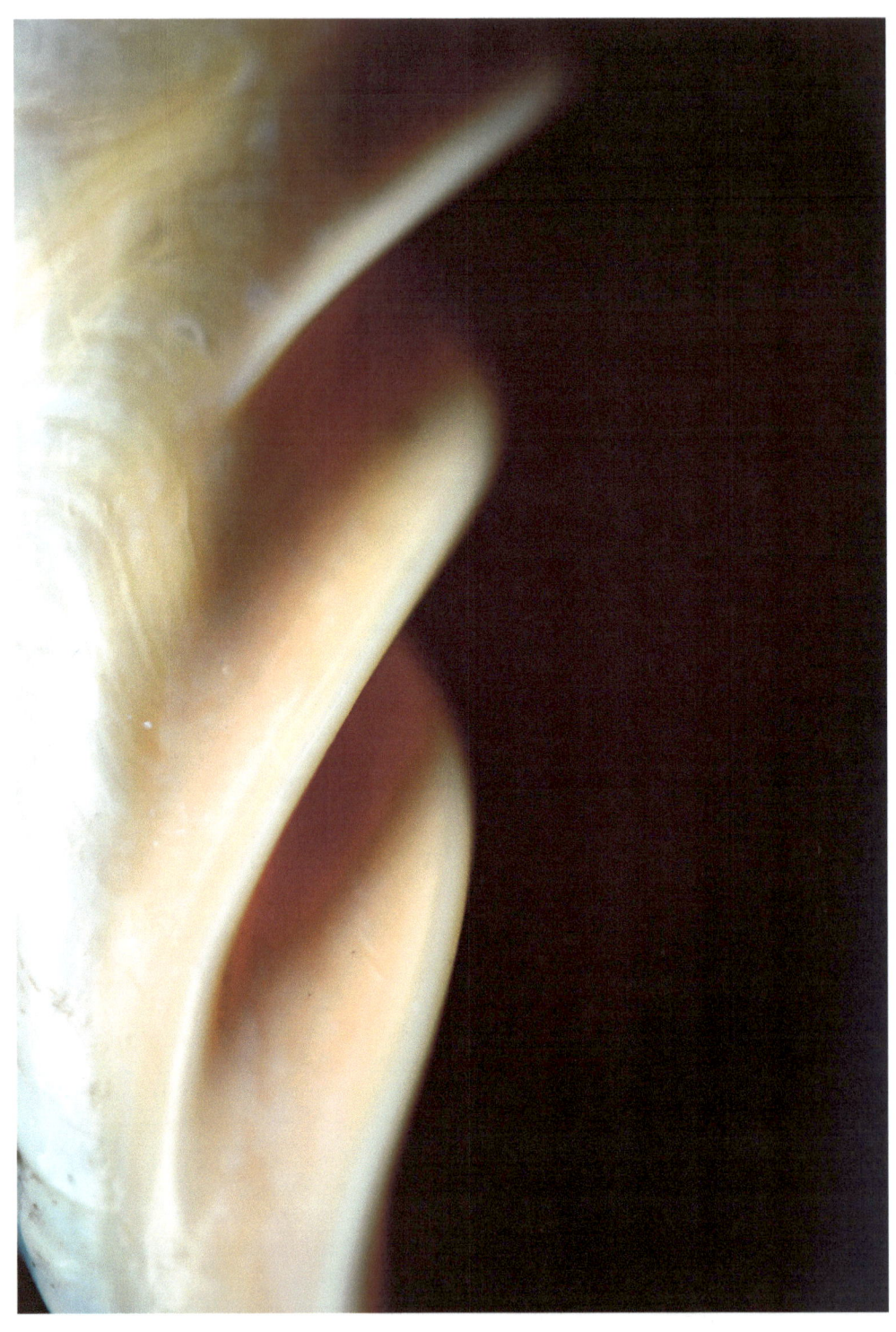

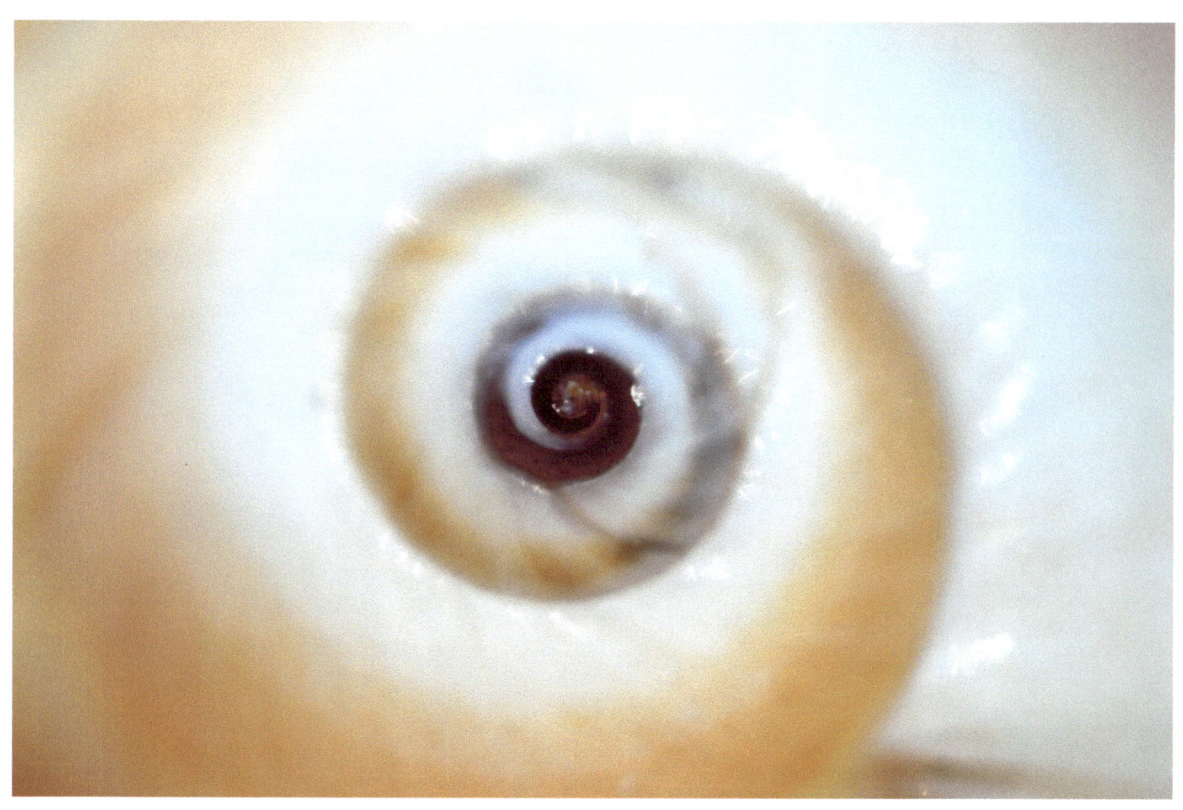

Spiral end of a moon shell

LEFT: helical fluting in the central column of a conch-type shell

THUMBNAIL: this picture of sea oats was accepted at the agency, but then I got carried away and tweaked it to create the additional images on the following two pages. Apparently they are a little too "artsy" for stock photography.

I Don't Know Much About Art But I Know What I Like

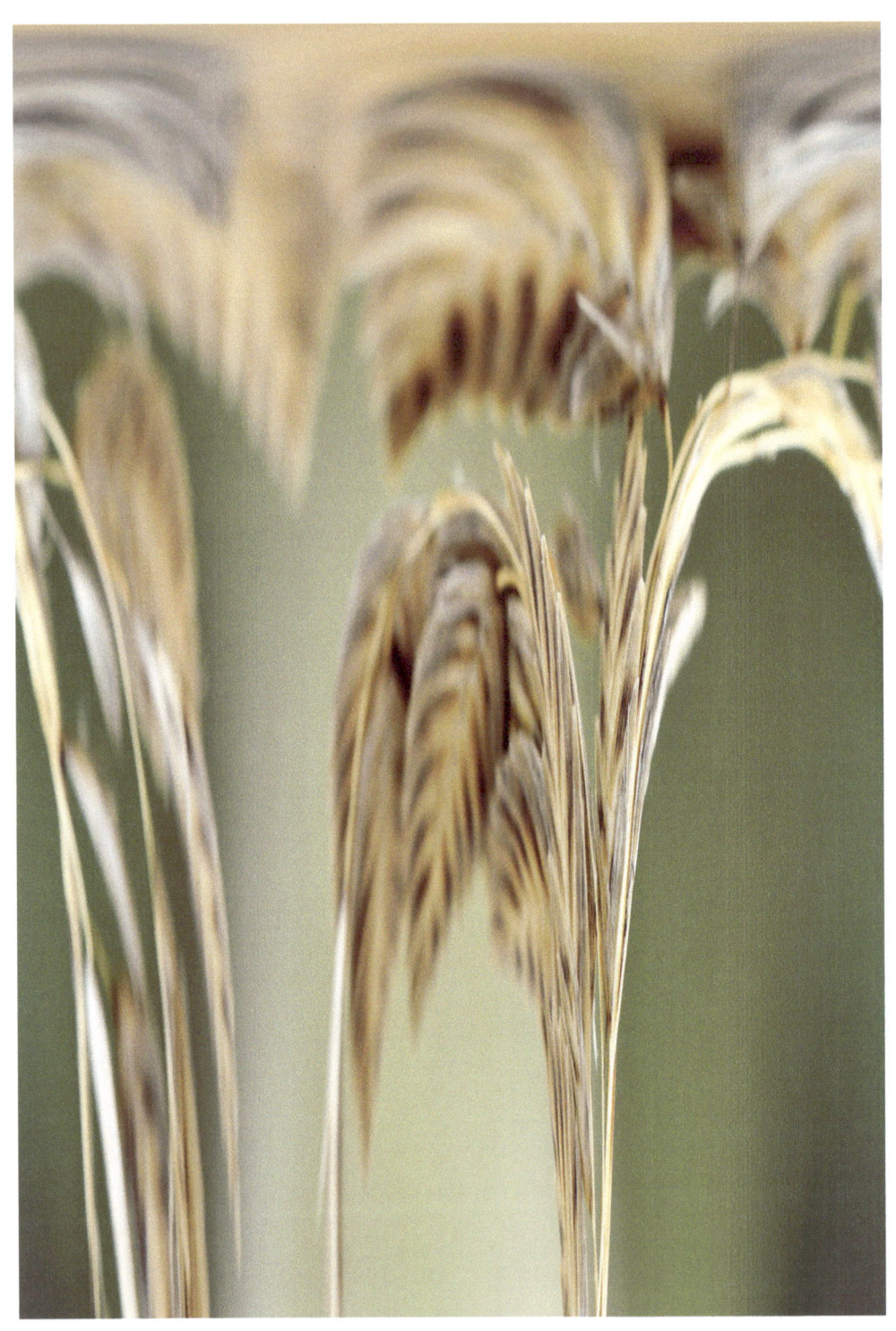

26 I Don't Know Much About Art But I Know What I Like

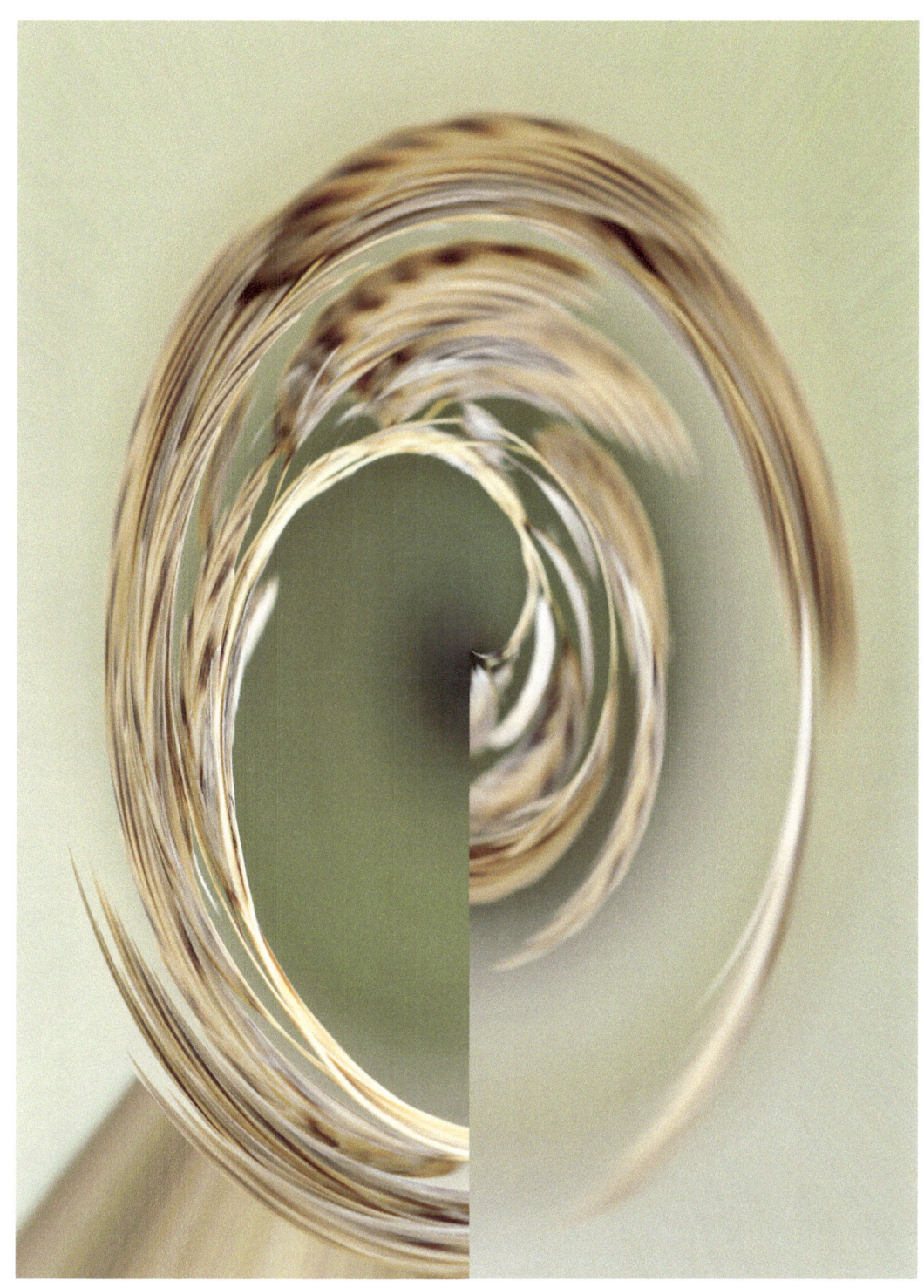

I Don't Know Much About Art But I Know What I Like

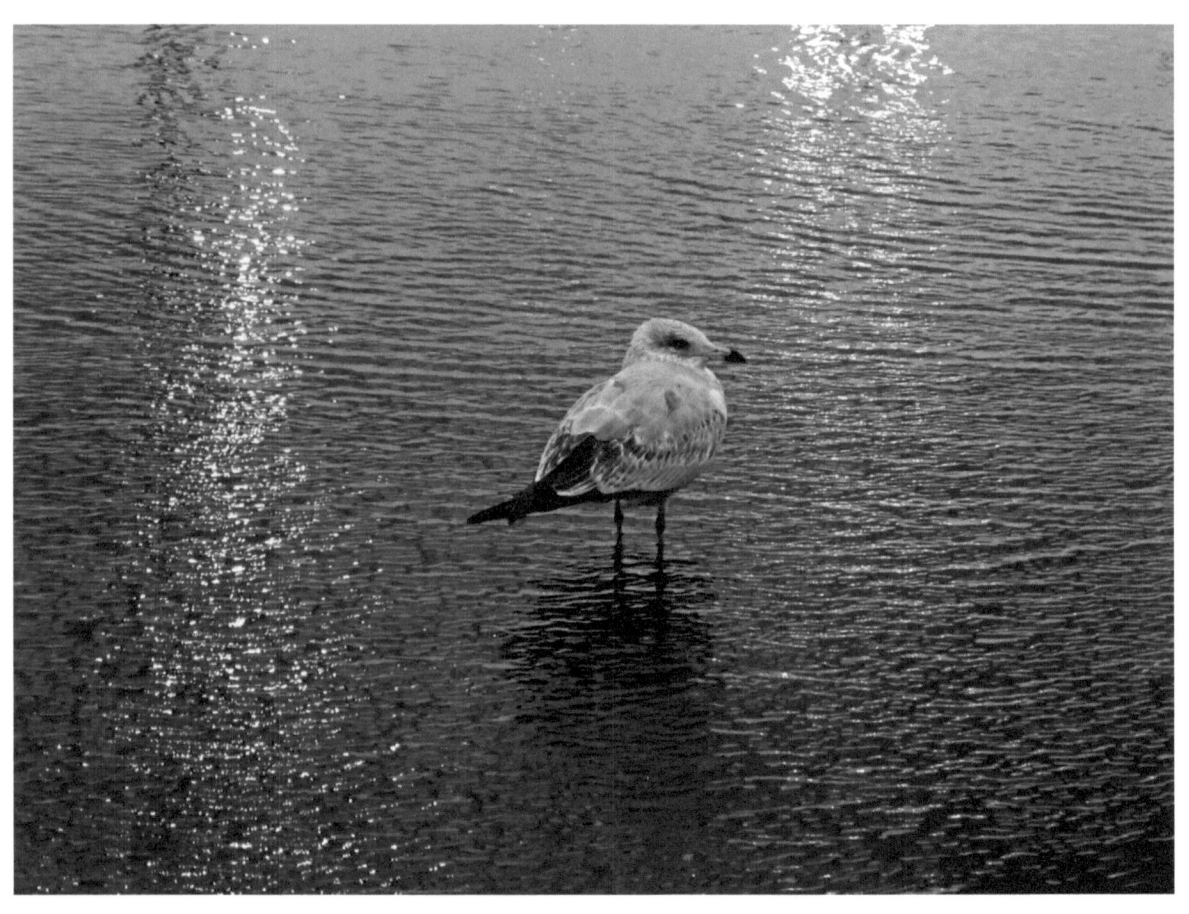

Seagull scavenging on a cold, rainy day.

RIGHT: Bumblebee gathering honey from Russian sage flowers.

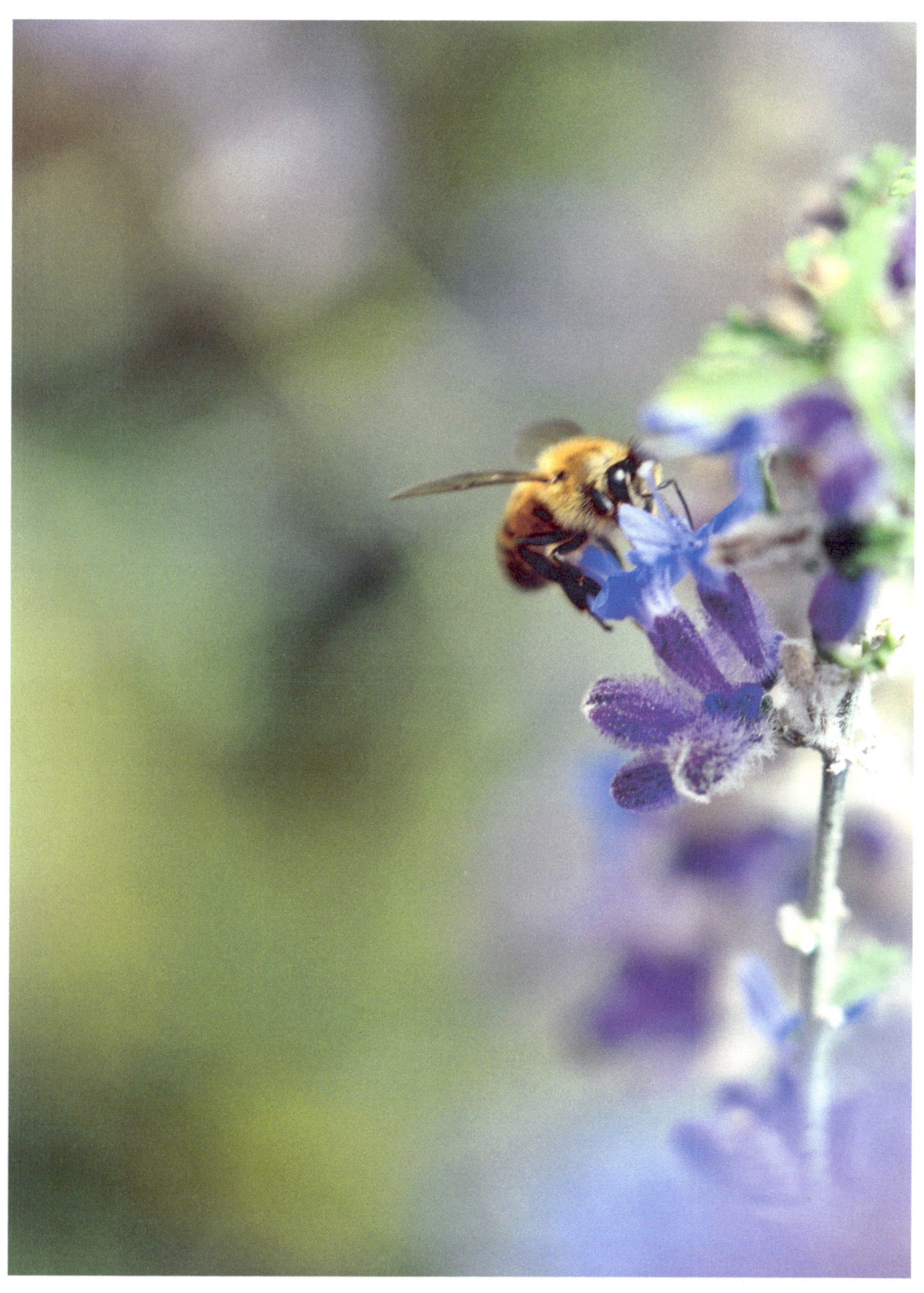

I Don't Know Much About Art But I Know What I Like

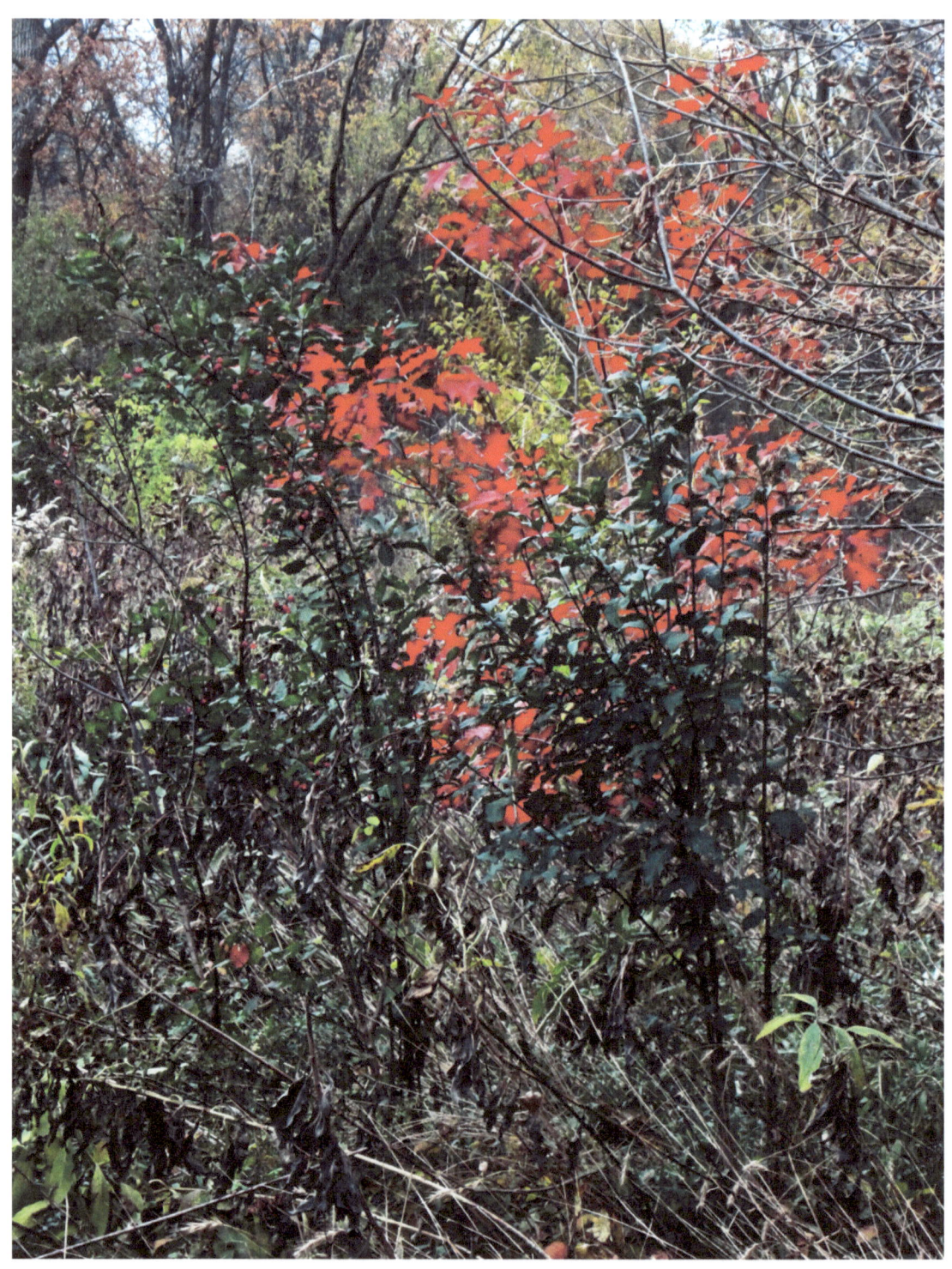

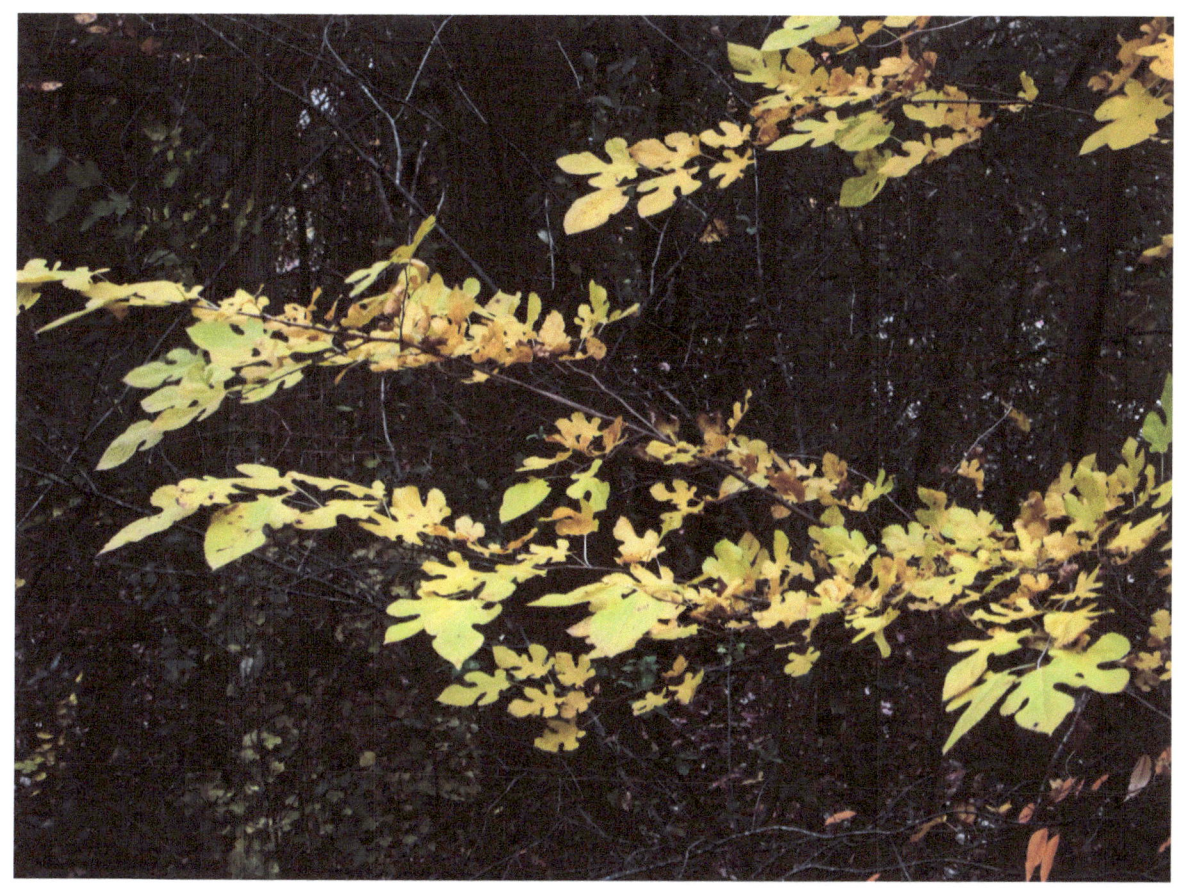

Vivid colors highlight the dull browns and greens of autumn. Runyon Preserve, Lockport, Illinois. ABOVE: Golden yellow sassafras leaves glimmer in the dim light of the forest. LEFT: A red oak sapling paints a red splash.

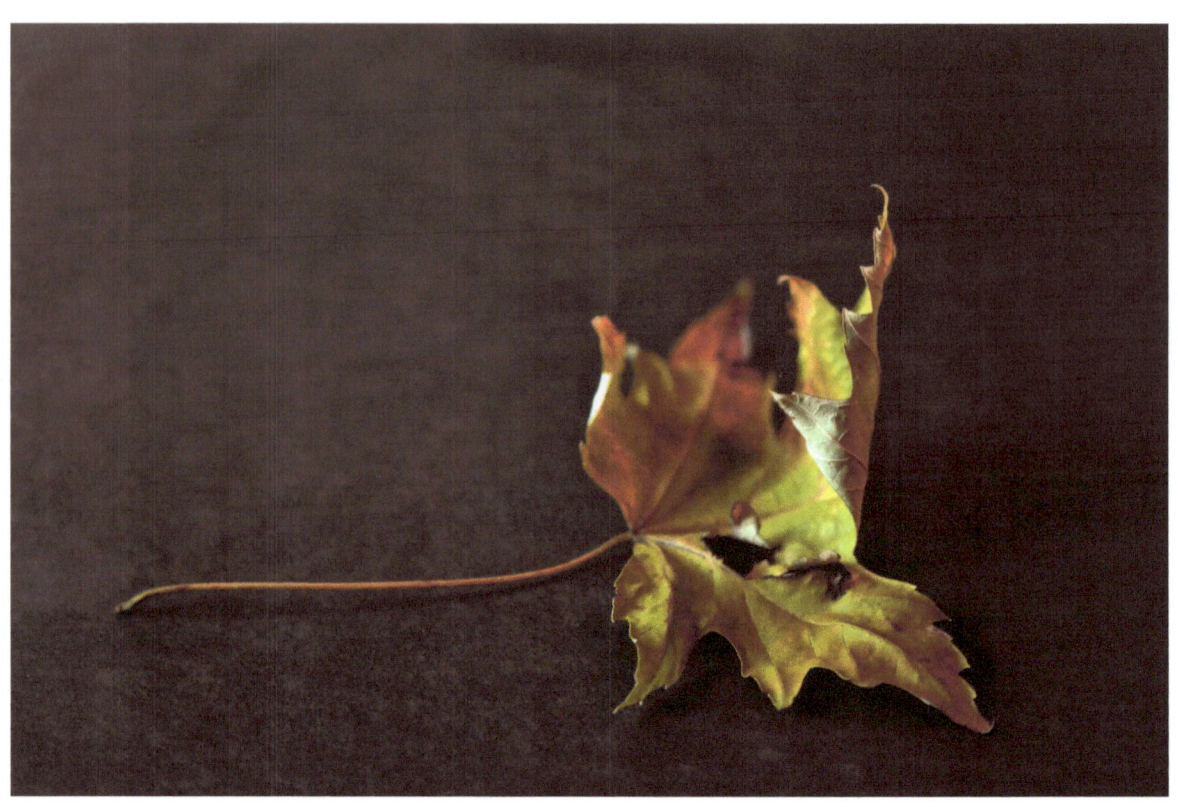

Dry, curling leaf of silver maple.

I wasn't satisfied myself with the picture of a branch of euonymus, below. Once again I got carried away with special effects. The result is far too "artsy" for stock.

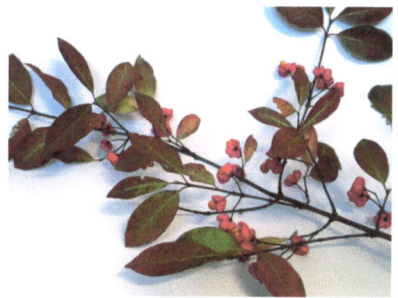

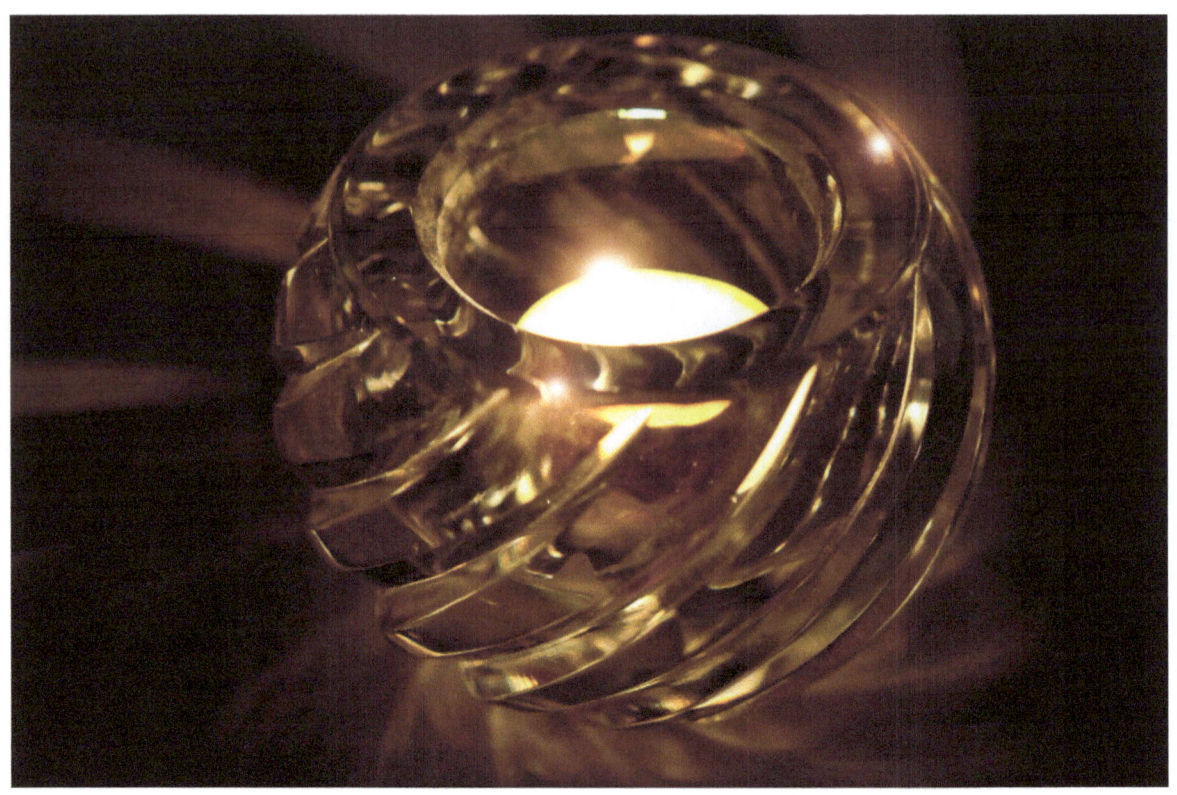

Here's a subject that captivates me: light and glass and the magic they work upon each other. The lead crystal votive holder was a lucky find for a dollar in the second-hand shop.

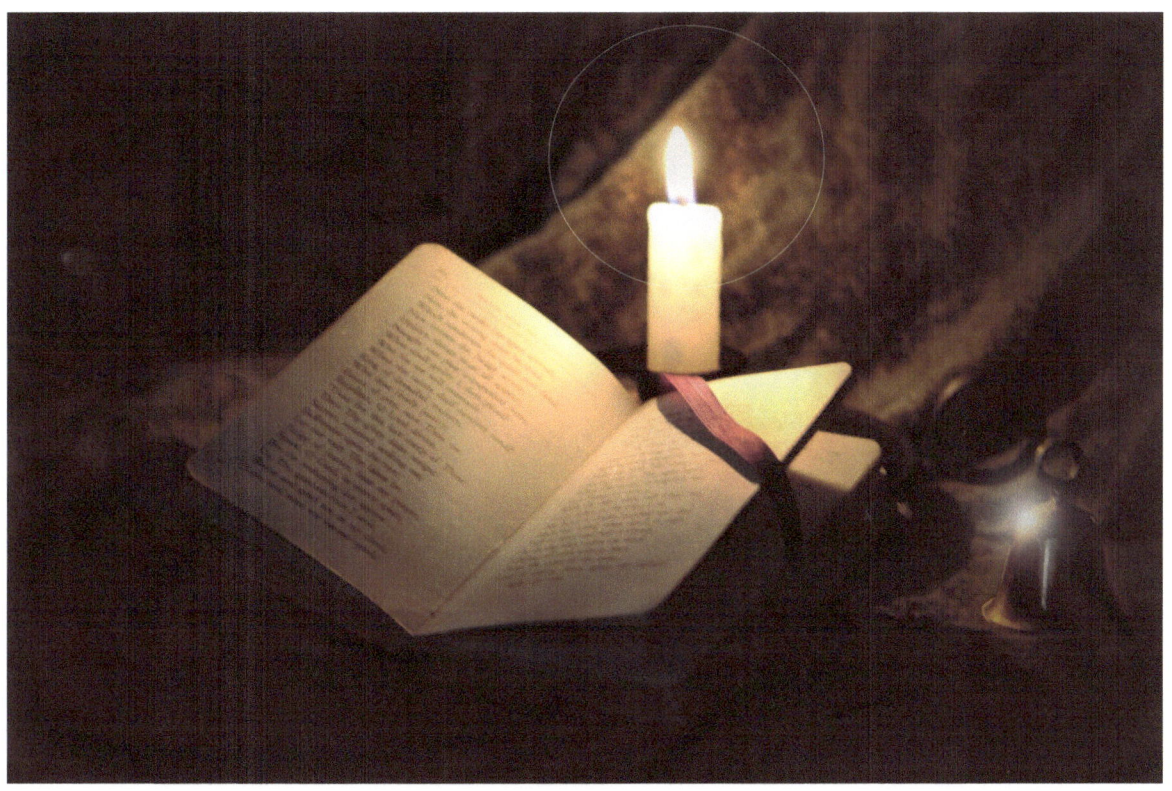

For Halloween, the instruments of exorcism: bell, book, and candle. The missal is opened to the ancient prayer *Dies Irae*, "Day of Wrath", from the Mass for the Dead.

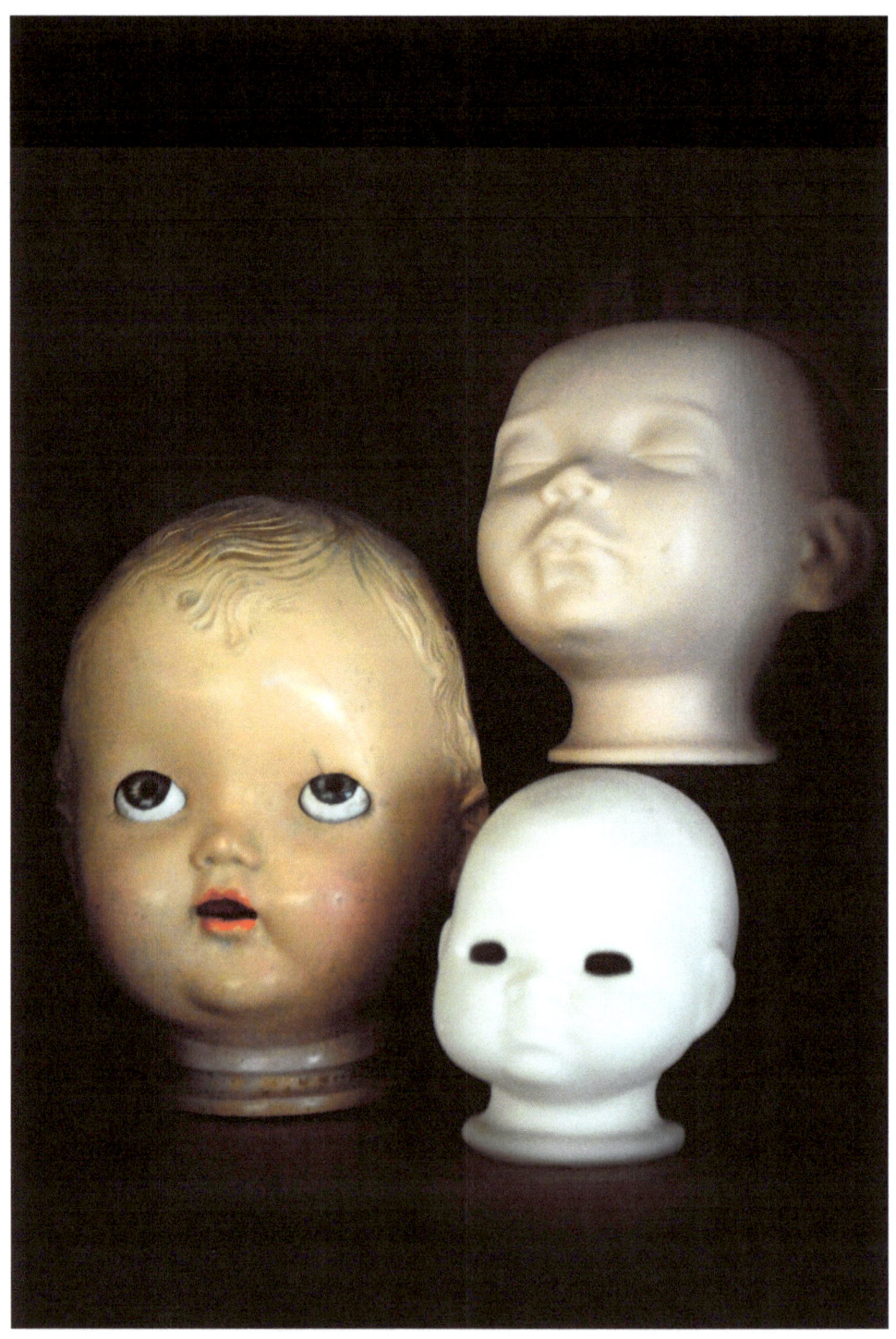

I Don't Know Much About Art But I Know What I Like

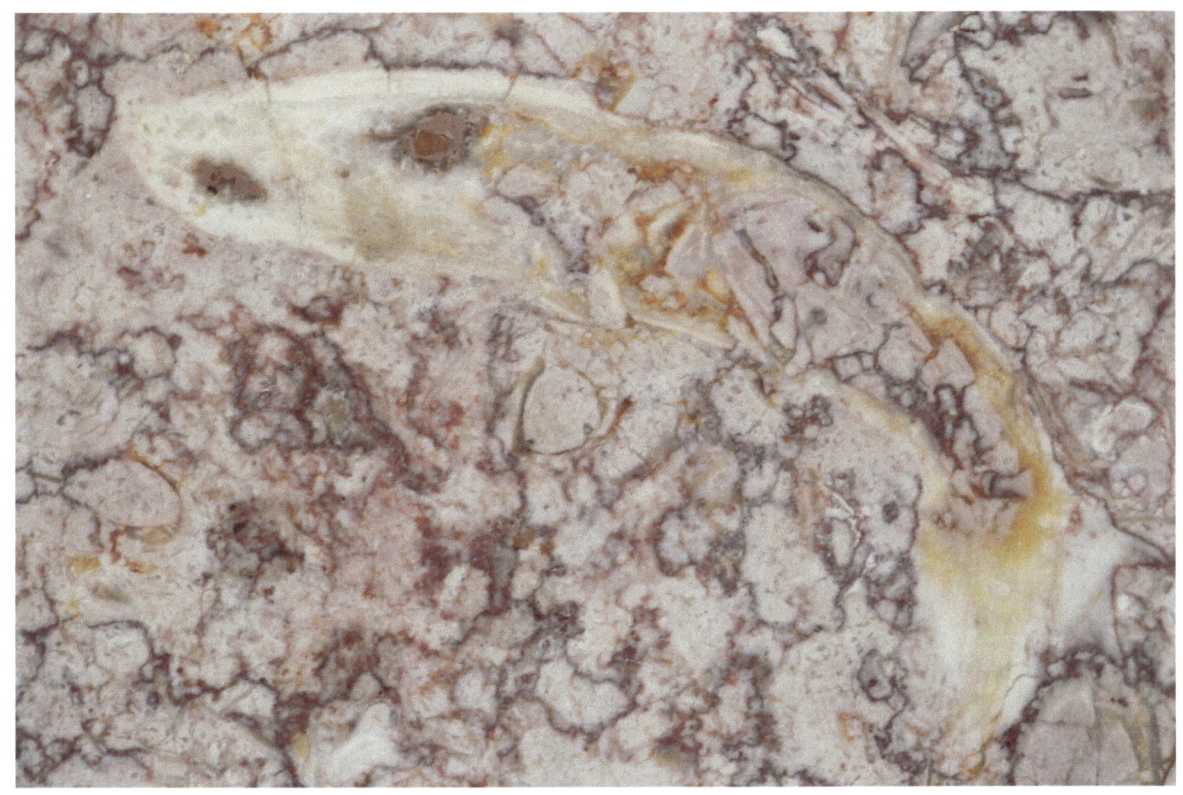

A fossilized fish swimming forever through the marble of my mother's prized coffee table, purchased at Marshall Field's long before Chicago ever heard of upstart Macy's. She told the salesman she wanted a fish in it like the one on the display floor. He replied that he couldn't promise her a fish as it would be shipped direct from the manufacturer. Mom was adamant—she wanted a fish. She ordered "on approval." When it came and we examined it, she whispered to me, "I think they sent me the floor sample," and she was thrilled. *"Give the lady what she wants."*

LEFT: my cousin's collection of dolls' heads, staring vacantly at nothing. I can't make up my mind which picture is creepier.

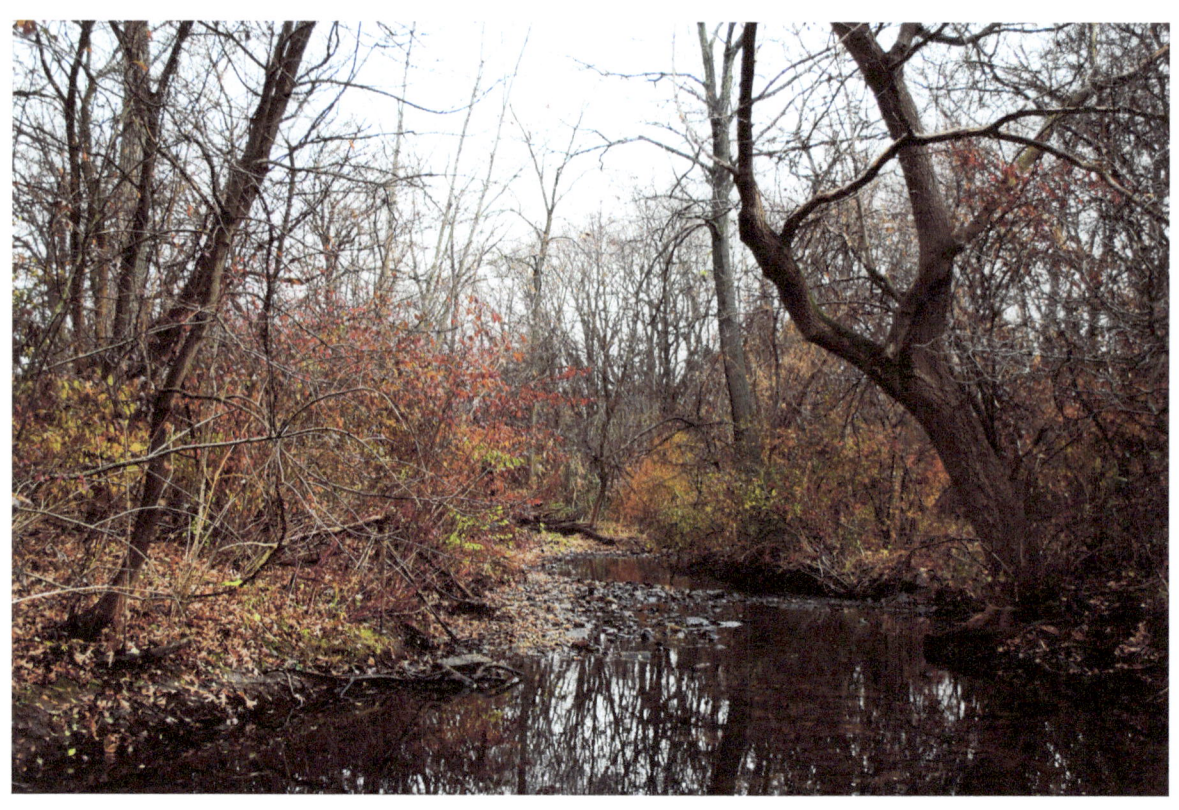

Fiddyment Creek in Runyon Preserve, Lockport, Illinois. Autumn color.

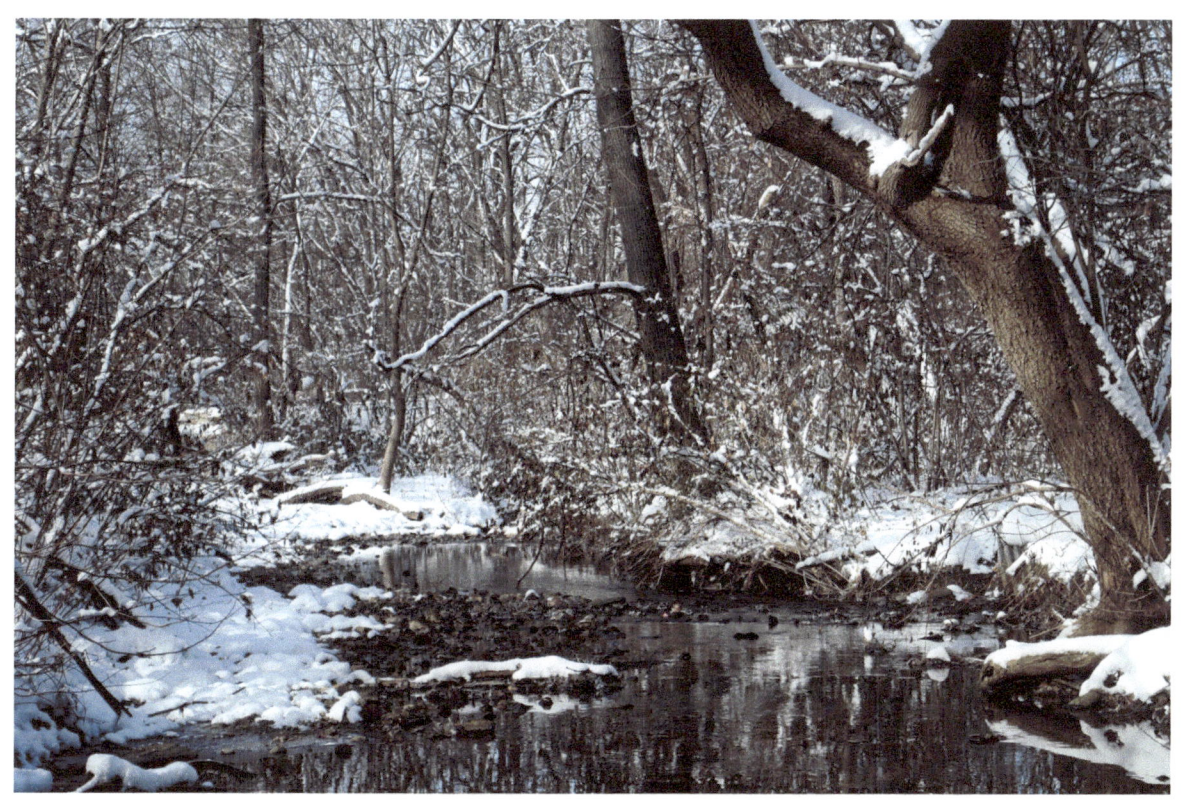

Fiddyment Creek in Runyon Preserve, Lockport, Illinois.
First snowfall of winter.

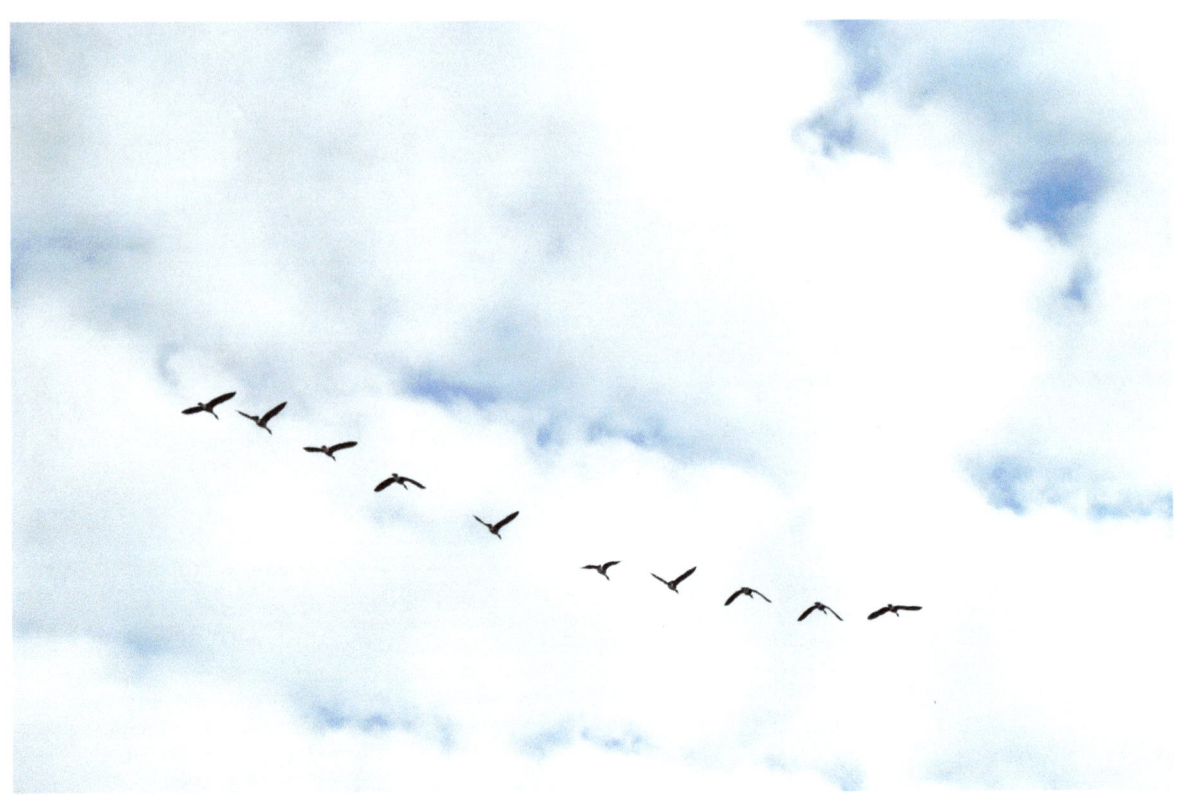

A string of Canada geese heading south for the winter.

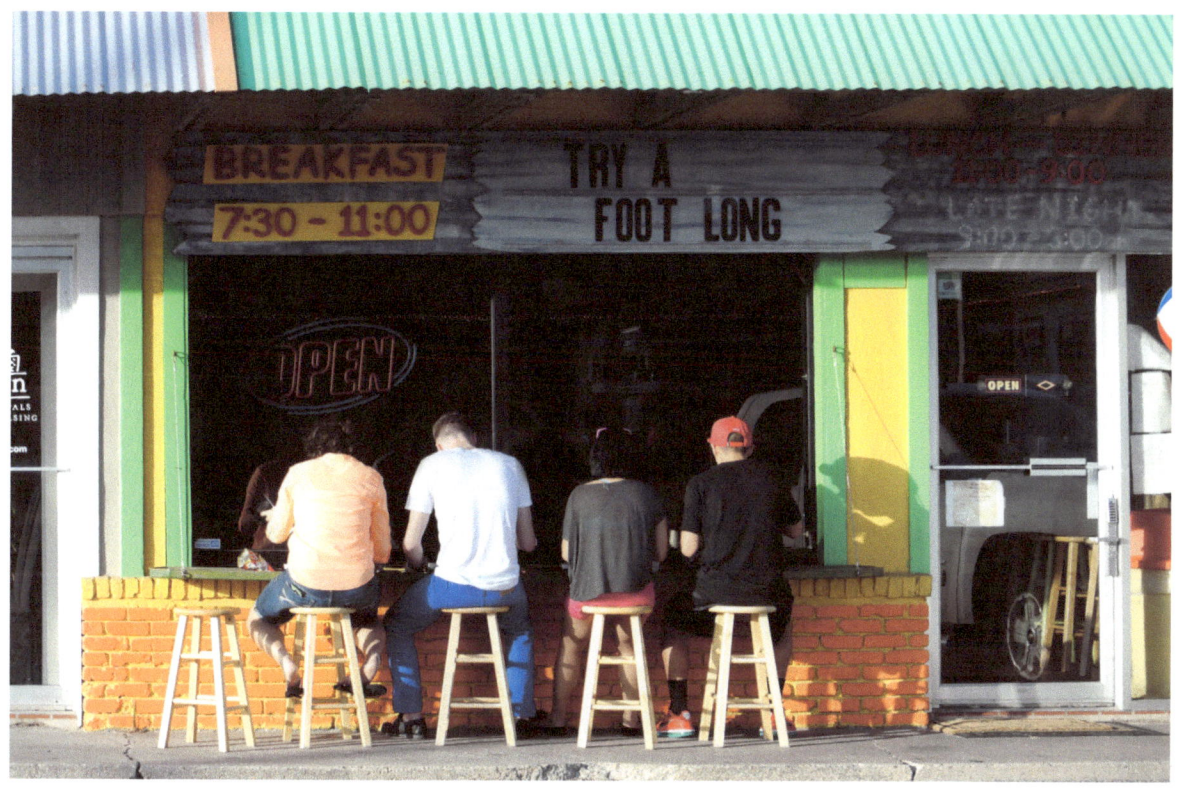

Another migratory species, the "snowbird" feeding in its winter habitat at Pensacola Beach, Florida.

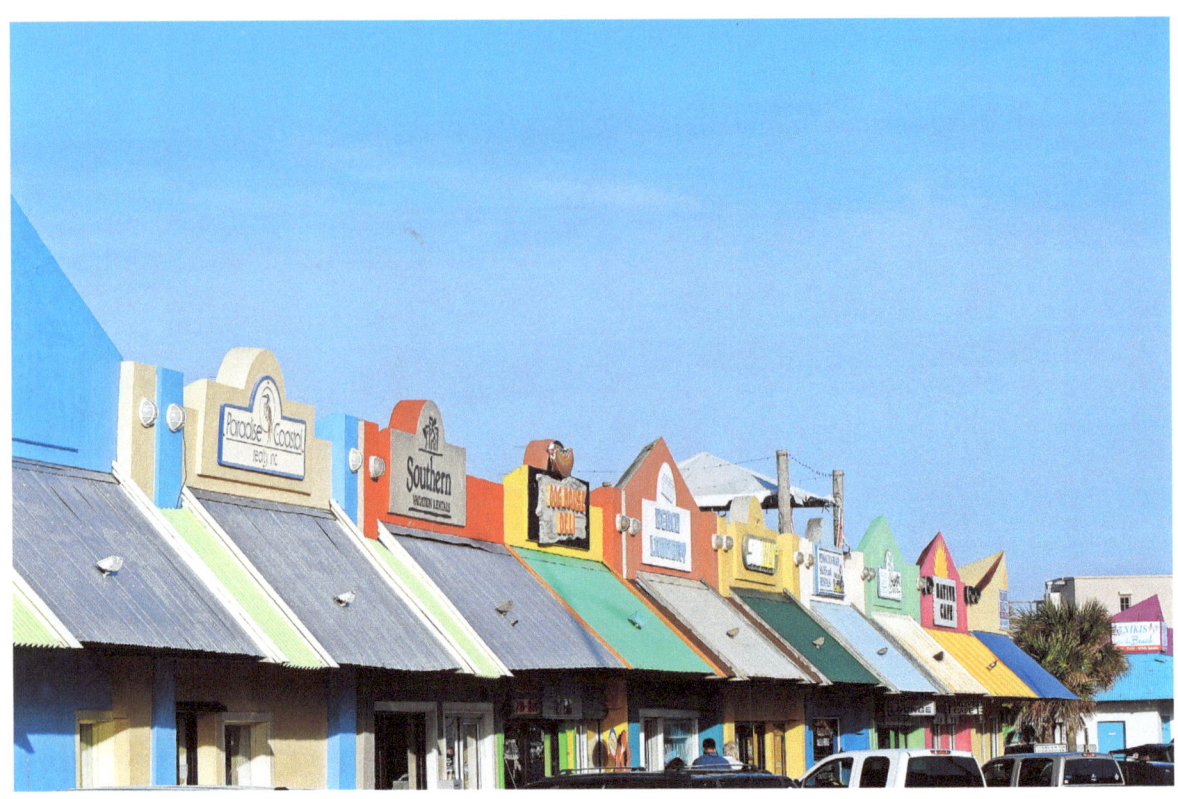

Apart from occasionally swapping colors among the shops, this little strip mall in Pensacola Beach, Florida, has remained much the same for the last half century.

RIGHT: A sidewalk along East Government St. in Pensacola, Florida. Covered sidewalks give some protection from the heat of the sub-tropical midday sun.

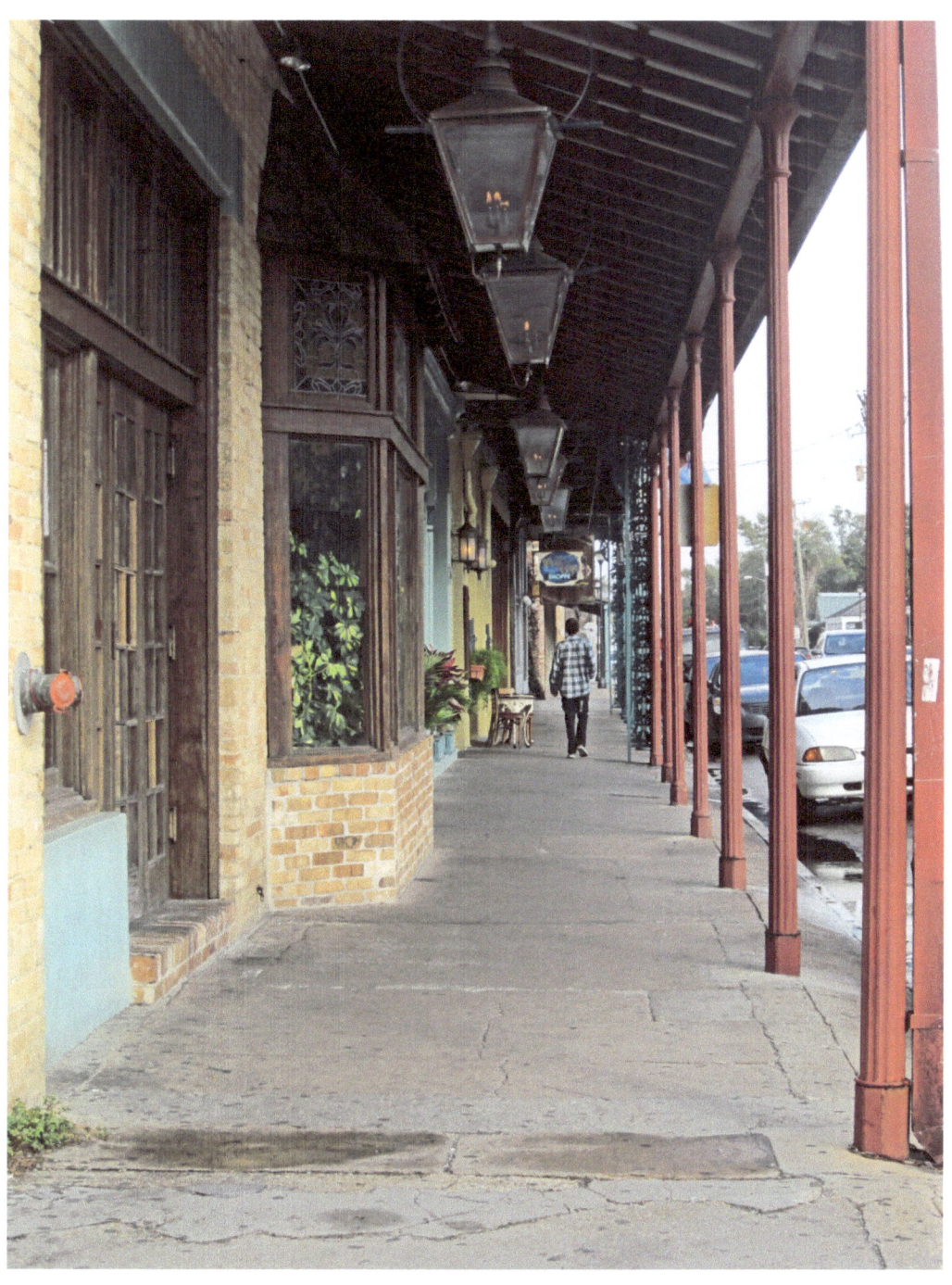

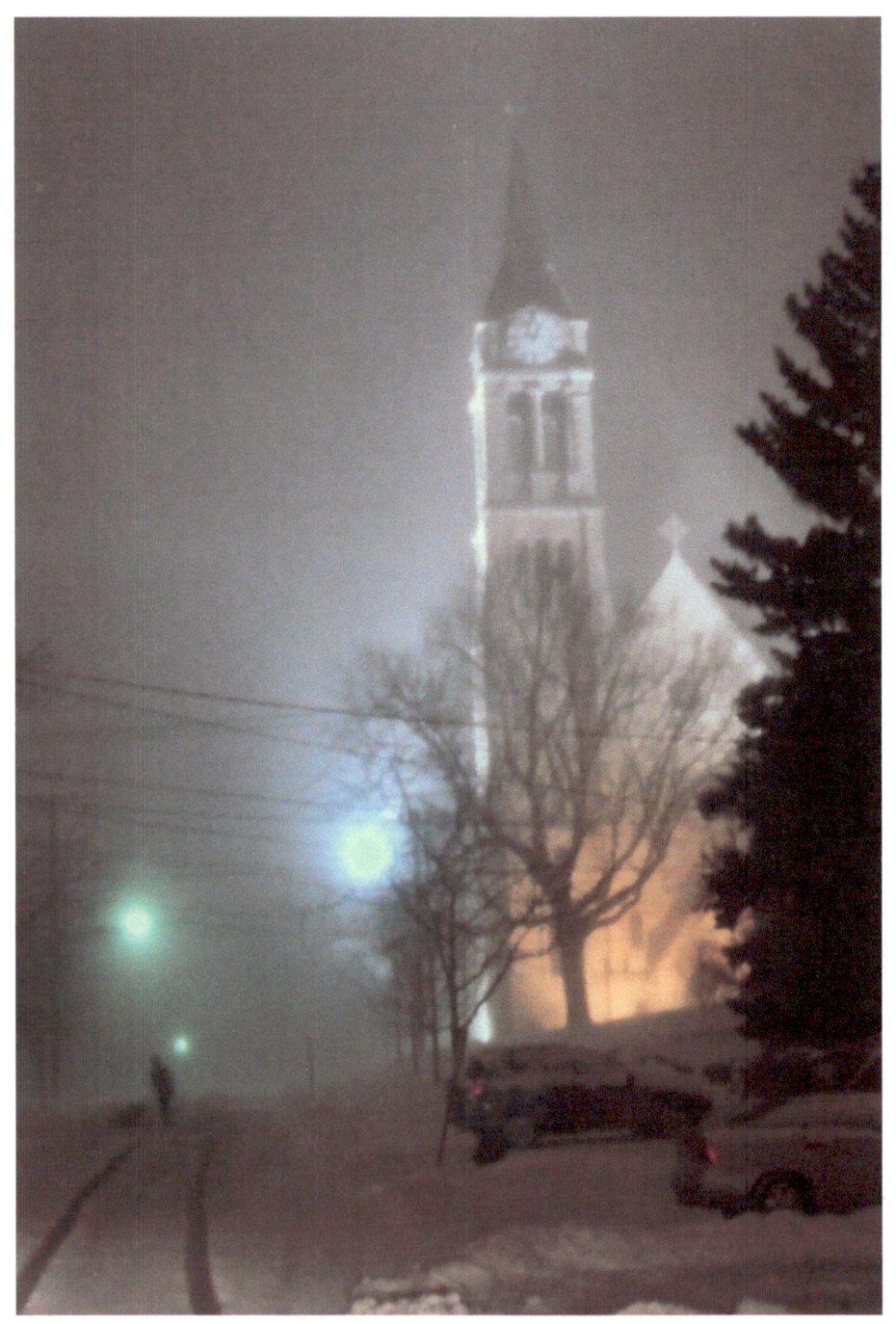

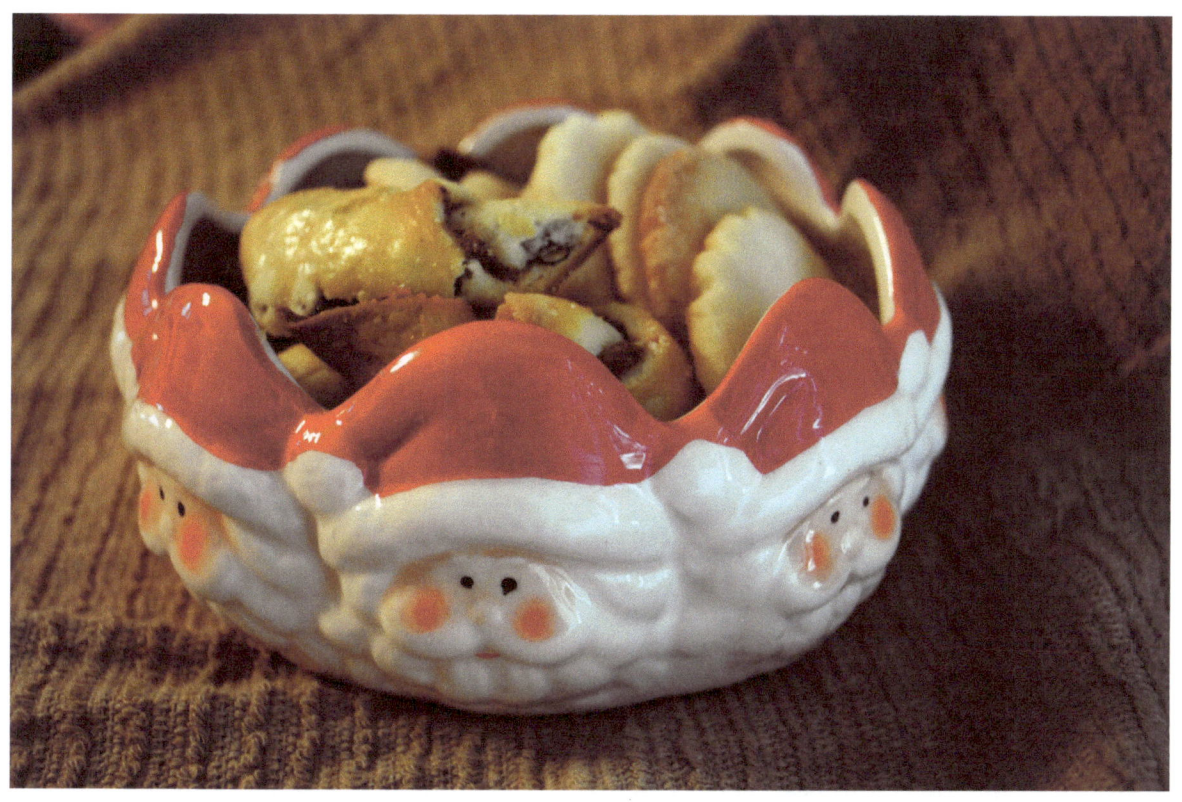

Nothing warms the heart like a dish of homemade cookies, a gift from a dear friend, every bit as tasty as they look.

LEFT: Here's what those snowbirds are missing: a true midwestern blizzard. St. Dennis church, Lockport, Illinois; February 2, 2011. More than two feet of snow fell overnight.

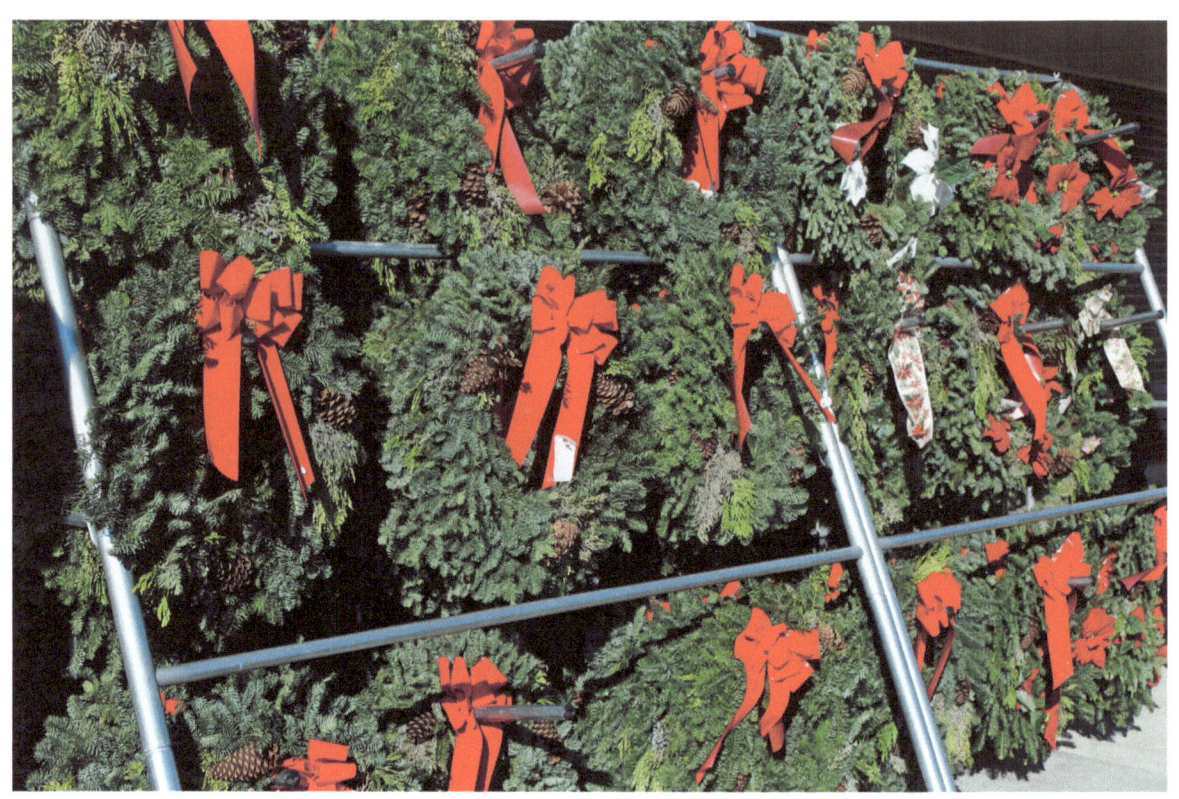

Holiday wreaths for sale at the market.

RIGHT: After the holidays, this poor tree was so exhausted its owner brought it to the lobby of the local clinic (where better?) to recover.

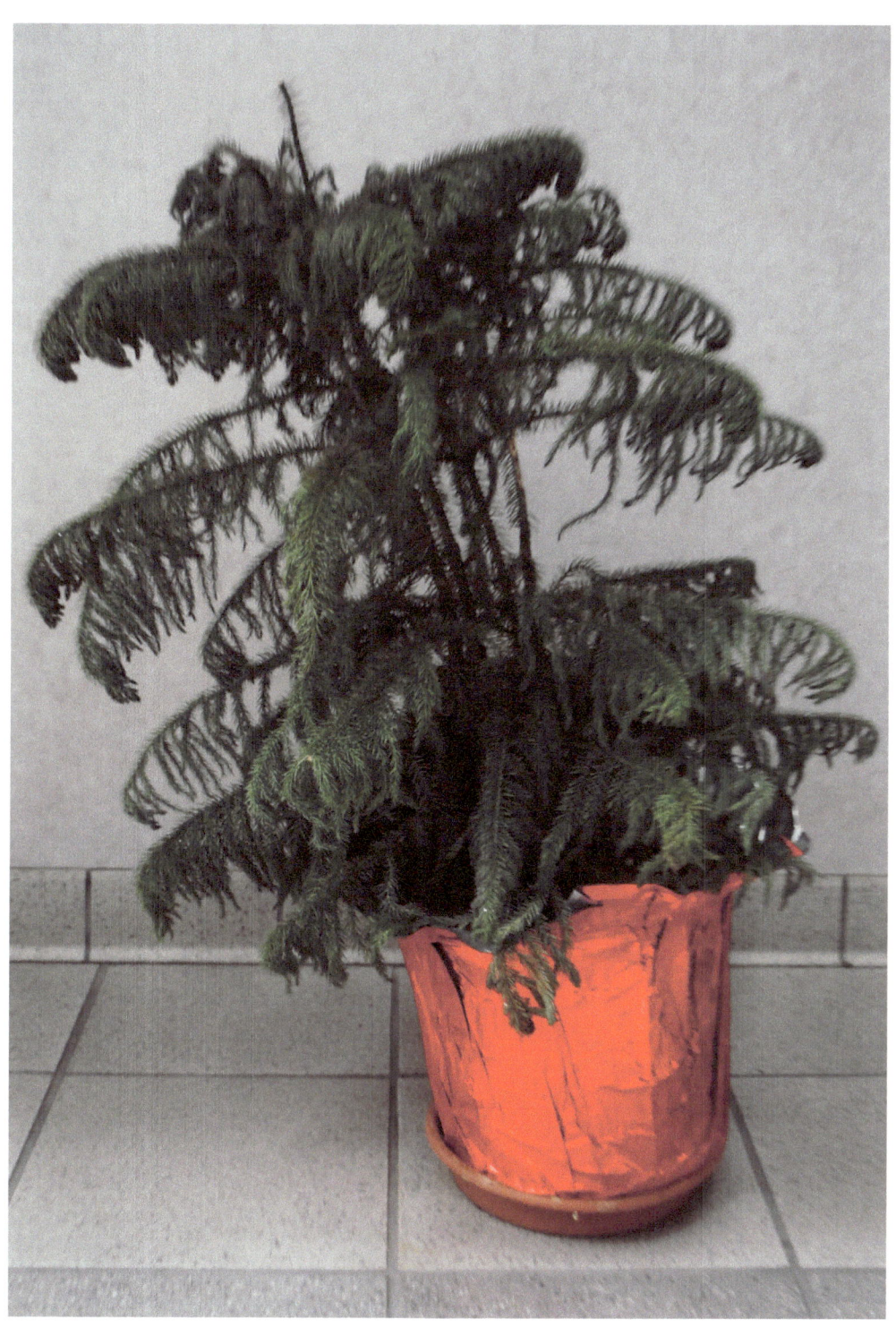

I Don't Know Much About Art But I Know What I Like

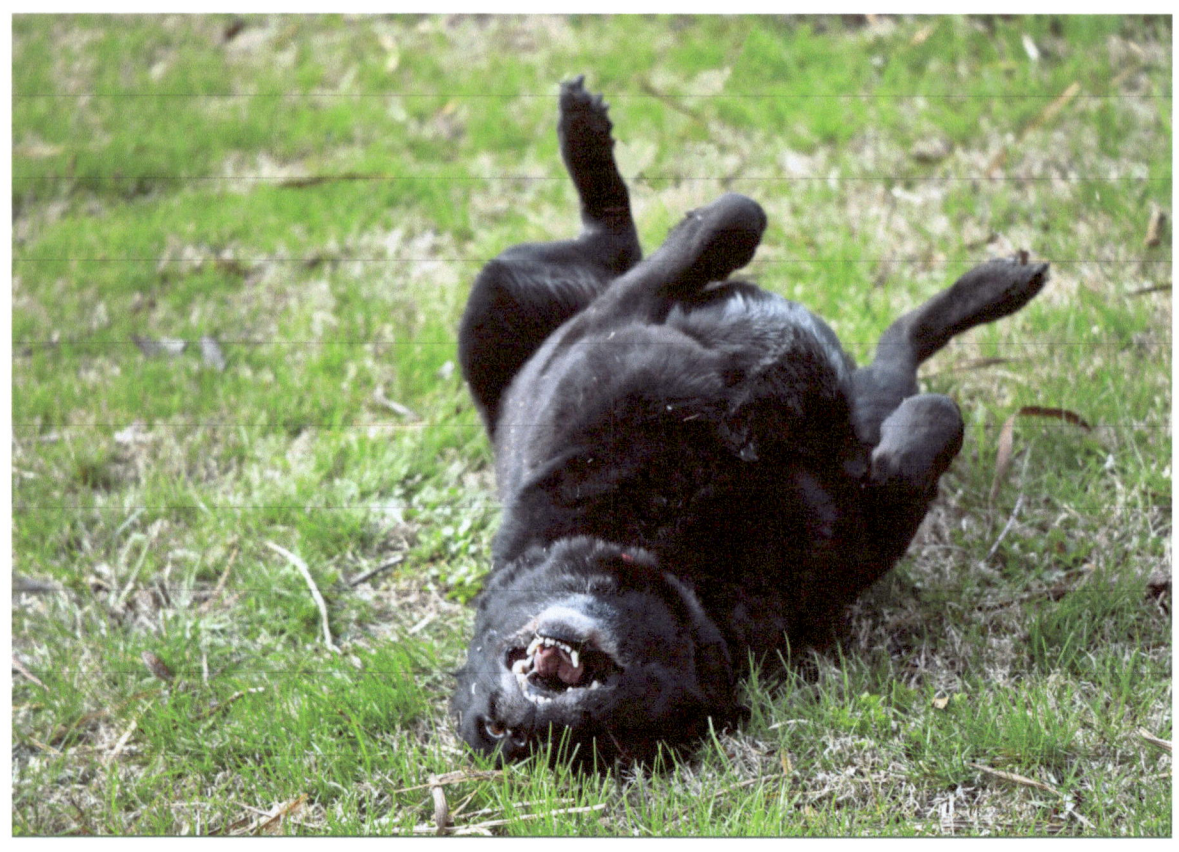

Thor wiggles ecstatically in the new spring grass. Nothing is better than the company of a friend who sees joy everywhere he looks.

COVER PHOTO: mackerel sky (cirrocumulus clouds). Some of the loveliest pictures are straight overhead. Keep looking up.

More works from this author:

Many of the author's works are available as posters, prints, and greeting cards from
 www.redbubble.com/people/marjorieb

The author's works which were *not* rejected are available for purchase as stock images at
 www.123rf.com/profile_mab0440/#mab0440

Visit the author's website at
 www.marjorieb-photos.com

Find the author on Facebook at
 www.facebook.com/MarjorieB.Photos

More works from the same family of creative artists:

The Storyteller by E. Treffry
 www.amazon.com 1469974525

Knucklehead, Bent-Arm and Thighbone by E. Treffry
 www.amazon.com 1478112921

www.ingramcontent.com/pod-product-compliance
Lightning Source LLC
Chambersburg PA
CBHW050808180526
45159CB00004B/1588